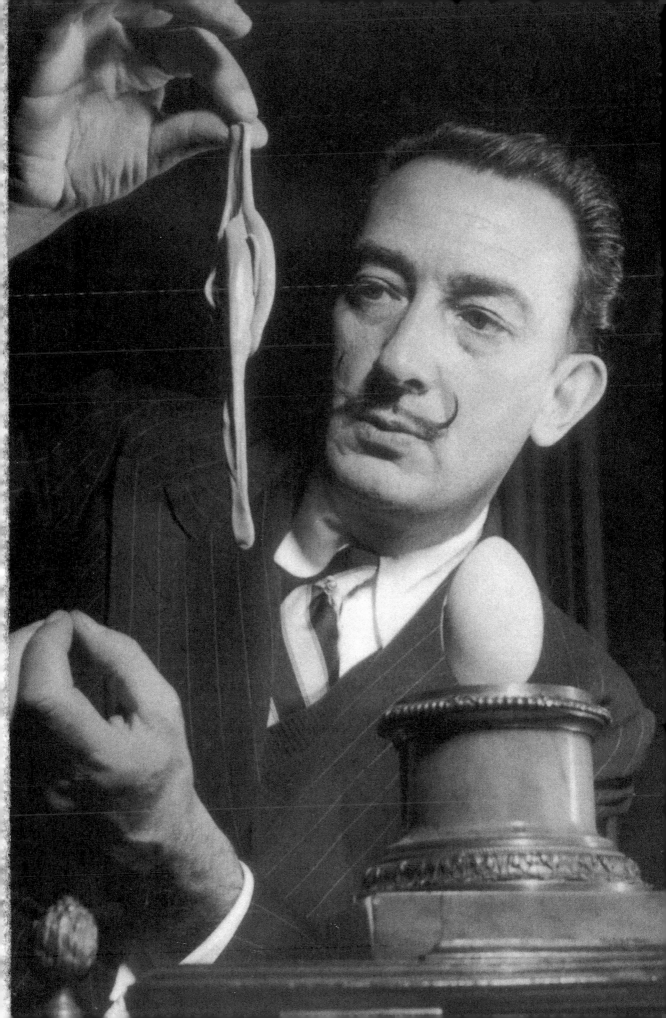

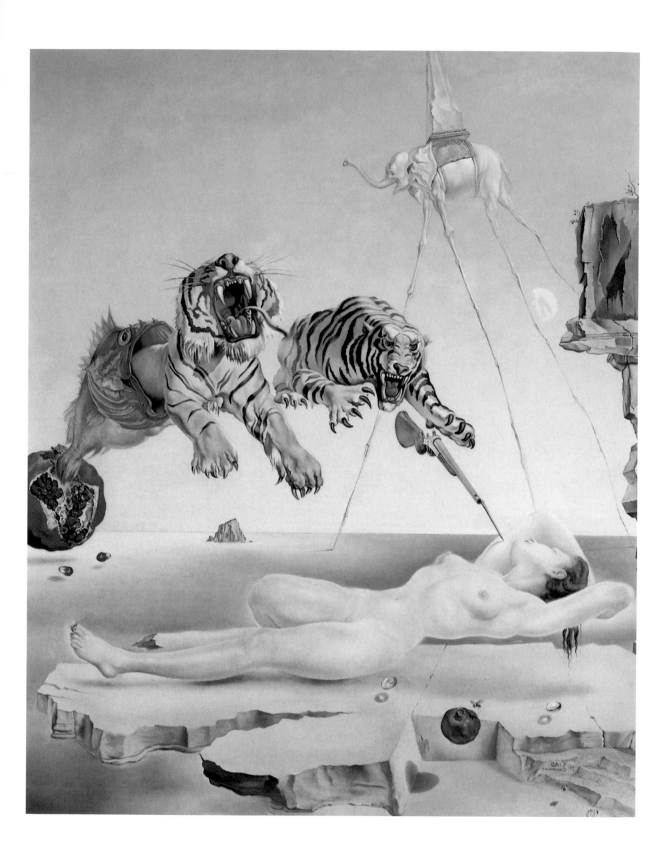

Ralf Schiebler

Dalí

The Reality of Dreams

PRESTEL

MUNICH · BERLIN · LONDON · NEW YORK

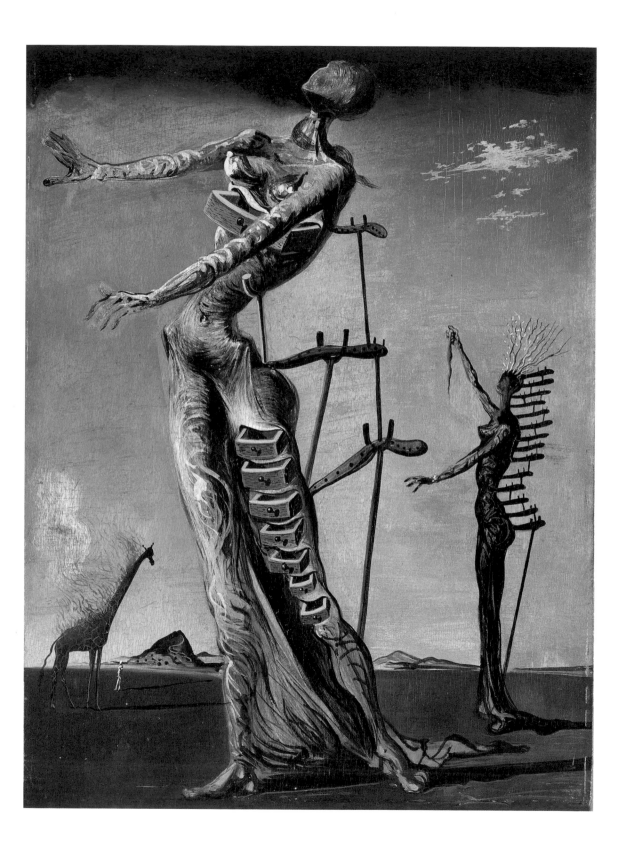

The Thirst for Fame

From earliest childhood there was something special about Salvador Dalí and, even before his talent for drawing and painting emerged, it was clear that he needed to be the centre of attention. In a carefully posed photograph taken when he was about seven, the child is sitting in the midst of a close-knit family: his father, his mother, and an aunt to his right, with a second aunt, his grandmother, and his sister to his left – all together on the rocky beach at Cadaqués, a landscape which was to appear in so many of his later works along with the fishing boat seen here in the background. It is perfectly obvious who has his hands on the reins here, who is the king of the castle: the child, sheltered and spoilt. A piece of string trailing artfully from the boy's hand seems to be hinting at some prank or scheme he is hatching behind that smooth forehead. And the string reinforces the sense that it is natural that he in particular should be chosen, showing that he of course dominates, protected by his father's authority in the background, yet already far beyond it.

When he was eleven or twelve years old Dalí, the schoolboy, baffled his classmates with a surprising offer: at playtime he set up a money-changing table and announced that he would buy five céntimo coins for ten céntimos each. Naturally his fellow pupils gladly exchanged their five céntimo pieces for ten céntimos as long as the supply lasted (from Dalí's parental home). They declared that Salvador was mad, while he himself claimed with consummate dramatic skill that he had made a mathematical discovery which would bring him untold profits. This episode shows that Dalí valued attention – any kind of fame or furore – more than money. At the same time, this incident neatly demonstrates the way that modern art relies largely on subventions and that, whatever its revolutionary leanings, above all it requires one thing: solid financial backing.

At about this time it was becoming clear that drawing and painting would be the most effective vehicles for Dalí's urge to impress others and win their admiration. His experiments in painting –

The Enigma of Desire, 1929, detail

7

depictions of cherries – are in line with the classical notion of art as striving towards the closest possible imitation of nature. His earliest surviving drawings (1917) are short comic strips, slapstick scenes which Salvador made to entertain his sister Ana María, four years younger than himself. His earliest published writing (1919) was a series on "The Great Masters of Painting:" Goya, El Greco, Dürer, Leonardo da Vinci, Michelangelo, and Velázquez. These early activities already demonstrated the characteristically wide-ranging nature of Dalí's thinking: the comic and the diabolic rub shoulders with serious classicism, levity and gravity are reflected to an equal degree.

The young Dalí had chosen those masters of painting as his role models. In a diary entry of 1920 he revealed his plans for the future: after passing his final exams at school, he would go to art school in Madrid, where he would devote himself to working only for the truth. He would then win a scholarship to study in Rome for four years. "Coming back from Rome I'll be a genius, and the world will admire me. Perhaps I'll be despised and misunderstood, but I'll be a genius, a great genius, I am sure of it."[1] The first stage went according to plan. Having passed the entrance examination he started his studies at the Academia de San Fernando in Madrid in September 1922. It must have been shortly before this that he completed his *Self-Portrait with Raphaelesque Neck*, adding another Old Master to his list of artistic inspirations.

What is Raphaelesque about this long, powerful neck? After all, it is Raphael's successor Parmigianino who is more readily associated with long necks. Certainly in Raphael's work there are also necks which are both graceful and strong – as in *The Marriage of the Virgin* (Pinacoteca di Brera) – although they most often appear on the female figures. This in itself would not have been a problem for Dalí, who was aware of his own androgynous potential. In the *Self-Portrait with Raphaelesque Neck*, the fine sweep of neck worthy of Raphael is combined with unmistakable attributes of obvious masculinity: long sideburns and a prominent Adam's apple, while the red mouth emphasises the feminine aspect of the image and the contradictory nature of the work as a whole. *The Bay of Cadaqués*, catching the evening light, is rendered in a loose-textured Impressionist style. The same technique used on the branches in the foreground, however, makes these seem casual, even scruffy. There is also a contra-

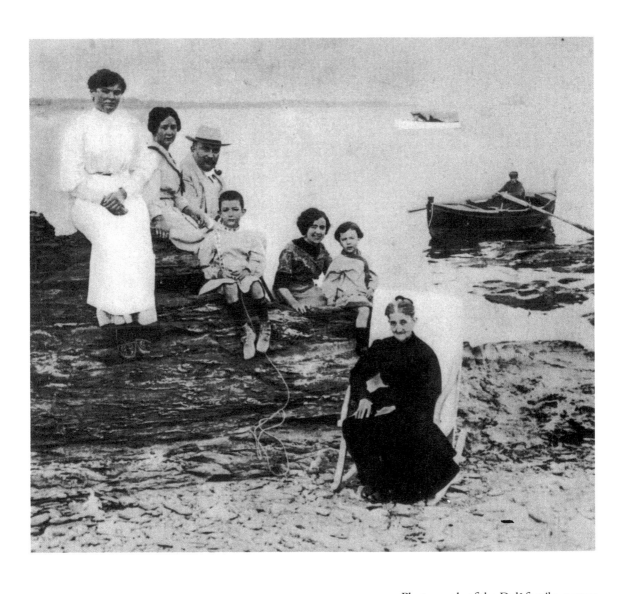

Photograph of the Dalí family, *c.* 1911

Stage Design for "Romeo and Juliet", 1942

diction between the calm, utterly concentrated eyes, mouth and forehead on the one hand and the more unkempt hair on the back of the head on the other, just as Raphaelesque refinement is juxtaposed with the sense of something dinosaurian and primeval, which the neck cannot deny. Here the rough and the smooth come together, tradition and modernity are as one. In the same way that Dalí admired Cézanne's "faire du Poussin d'après nature," in this work of his own, he has created an Impressionist Raphael.

Raphael did of course paint some male figures whose necks have a strikingly beautiful line (even if the delicate curves are obscured by hair) including the *Portrait of a Young Man* (Budapest), the *Portrait of Angelo Doni* (Palazzo Pitti), the *Portrait of a Cardinal* in the Prado and, not least, the self-portrait on the far right in the *School of Athens* (in the Vatican), in which the neck is, in fact, at the same angle as the neck in the Dalí painting. Dalí was to return to these Renaissance models at a later date, as in his (unrealized) *Stage Design for "Romeo and Juliet"* of 1942. A list that Dalí made in 1948 giving scores to painters according to various criteria such as originality, technique and so on, shows clearly how highly he rated Raphael: he is ranked second, just behind Vermeer and ahead of Velázquez, Leonardo da Vinci, Dalí himself, and Picasso.

The fame of the great figures of Renaissance art rested above all on their intellectual accomplishments. Painting was emancipating

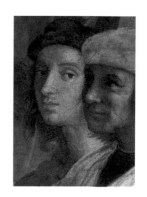

Raffaelo Santi, *Portrait of the Artist,* from: *The School of Athens,* c. 1508 – 11

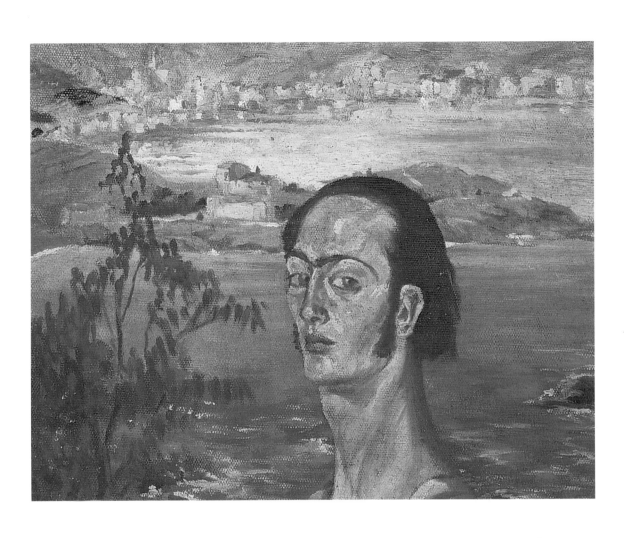

Self-Portrait with Raphaelesque Neck, 1921 – 22

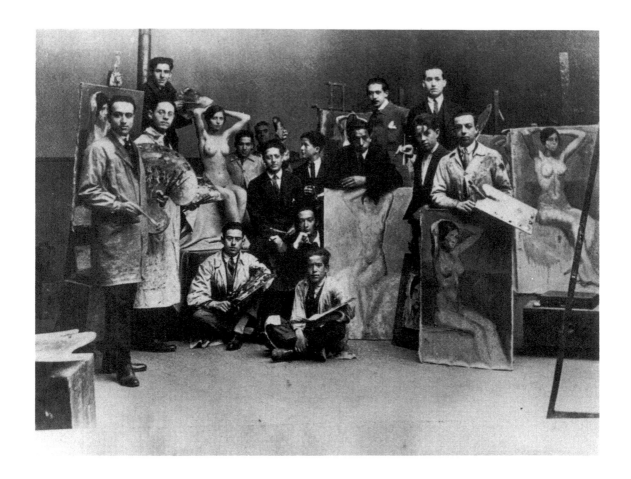

itself from its status as a craft to that of a science. Narrow religious
attitudes were opening out into humanist universalism. In a photo-
graph showing Dalí in the centre of a group of students during his
first year at art school, he is unencumbered by painting utensils or
some only too interchangeable example of his work. It is as if he
alone were aware that the very name of the institution where he is
receiving this education goes back to a school founded by a philos-
opher: Plato's Academy. With his chin resting on his hand, he pre-
sents himself in the pose of the thinker, and the whole scene, though
not in fact a product of his imagination, would seem to be under his
charismatic spell.

 Dalí, having discovered the relatively sensual qualities of Impres-
sionism and Pointillism, then turned to the much more conceptual
notion of Cubism, a movement that his professors and fellow students
were barely aware of although it had existed for almost fifteen years
by then. His subsequent *Cubist Self-Portrait* was a signal that Dalí had

Photograph of Dalí
at the Academia de
San Fernando,
1922/23

caught up with and joined the avant-garde. At the same time, the spreading cascade of crystalline facets (with the spectrum of Impressionist rainbow colours restricted to an ascetic grey-blue), demonstrated the many-sided virtuosity of this artist. The mouth, which had received such emphasis before, has completely disappeared. Its function is replaced by the communicative power of a newspaper, one with a name "Publicidad," which refers to two essentials for any artist to become famous: publicity and exposure. As it so happens, Dalí was a first class strategist in the matter of publicity. Even those who might not see him as an outstanding painter would not deny that he was a publicity genius. Long before Andy Warhol remarked that anyone could be grateful to be "famous for fifteen minutes," Dalí prided himself on his fame in a world flooded with celebrities and publicly familiar images. "It is difficult to hold the world's interest for more than half an hour at a time. I myself have done so successfully every day for twenty years."[2] Instinct told him early on that the real experts in advertising were evolving in the United States. In December 1936 *Time* magazine marked Dalí's second journey to the USA with a Man Ray portrait of him on the front cover. It was an extremely unusual distinction for any visual artist to be featured so prominently in a national magazine, an honour not to be repeated until *Life* ran a large feature on Jackson Pollock in 1949.

By the age of eighteen, Dalí had already participated in two group exhibitions and had received several favourable reviews in newspapers in Figueres and Barcelona. Success breeds success, but Dalí was careful to tighten the reins somewhat since a stream of positive reviews would only suggest that his art was within the grasp of the critics. He therefore constantly increased the element of provocation in his works and juxtaposed widely differing styles in exhibitions. The critics were still just able to keep up, declaring that "Dalí plays two apparently opposing cards, the 'traditional card' alongside the 'card of audacity.'"[3]

The stylistic diversity of the year 1923 ranged from the *Cubist Self-Portrait* through the Pointillist *Bathers of Es Llaner* to *Cadaqués* with its return to Classical, Mediterranean order. The hectic atmosphere of Madrid, where Dalí created the former painting, was a far cry from the cheerful summer idyll of the fishing village on the northern Costa Brava where Dalí's father came from and where the

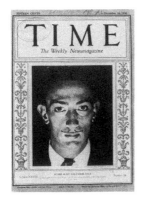

Cover *of TIME,*
14. December 1936,
photograph by
Man Ray

13

family had a holiday house by the beach of Es Llaner, the inspiration for the latter two works. It is a happy, peaceful world, where a glassy sea harmonizes with a gently floating hot-air balloon, an Arcadia filled with the sheer joy of living of the young girls with their gently rounded forms.

Port Alguer is a synthesis of Cubism and Realism, considerably helped by the fact that the village Cadaqués is already very cubic in its construction. (As chance would have it, Picasso had spent the summer of 1910 there on the invitation of the painter Ramón Pitchot whose family also knew the Dalís. It was some years later during a stay at the Pitchots' country estate, Molí de la Torre near Figueres, that Salvador was first to find what painting meant to him.)

There is a photograph which records how this picture came into being: Dalí has set up his easel facing the sea although his subject matter is to his left, actually behind him; he himself is looking to the right towards the photographer. Despite the work's faithful representation of the scene (as the photograph shows), the point here is that the artist is painting "from his imagination," unlike run-of-the-mill painters who would have set the easel facing the motif and still perhaps have only managed a poor likeness. The scene reminds us of the photograph of Dalí in his art-school class (p. 12) showing the contrast between a roomful of dull representations of the model and the theoretician in the middle whose results are completely unpredictable. In somewhat the same way, Dalí, as a student, when once asked to copy a statue of the Holy Virgin, painted a set of scales.

Vagaries of this sort create an eccentric image. But it would not be right to say that what Dalí did as an artist was purely motivated by the pursuit of this image. A much more important factor was his delight in his own virtuosity and the sheer pleasure he took in setting himself increasingly difficult tasks that went far beyond the usual demands. This did not alter the fact that he nevertheless welcomed the reputation and the renown that resulted from his natural leanings[4], a reputation which may well, in turn, have strengthened those leanings. In the process, Dalí was learning that a controversial, negative image would do more for him in the long run than instant approval, which means that we cannot entirely dismiss the notion of provocation for provocation's sake in his case as a kind of limbering up. But behind it all, it was clear to Dalí that his high ambitions could only be attained by hard work at the most demanding level. His

Cubist
Self-Portrait, 1923

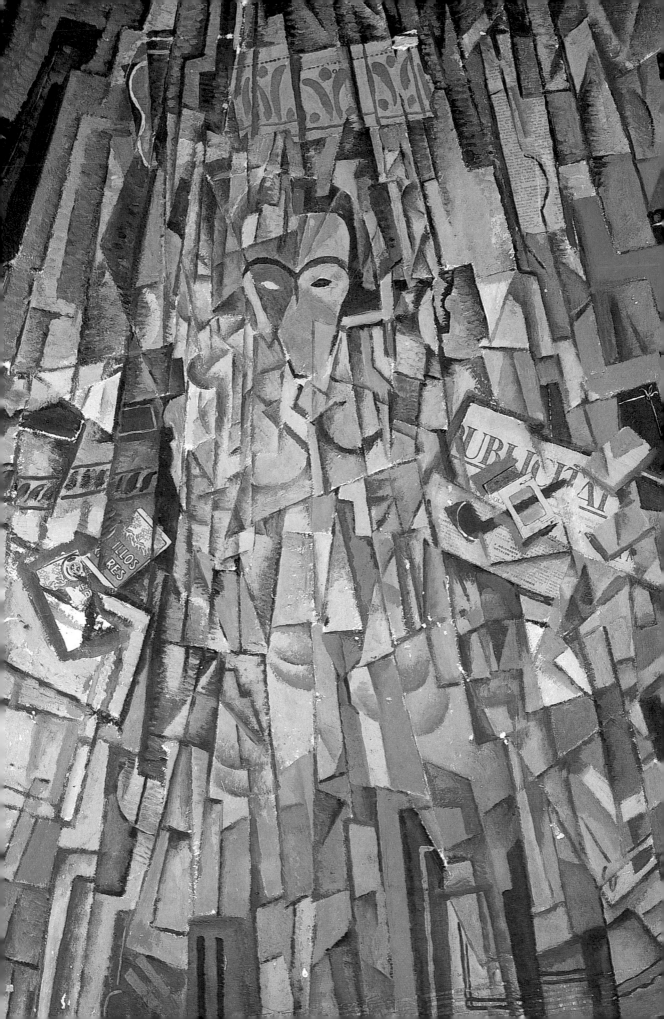

Bathers of Es Llaner, 1923

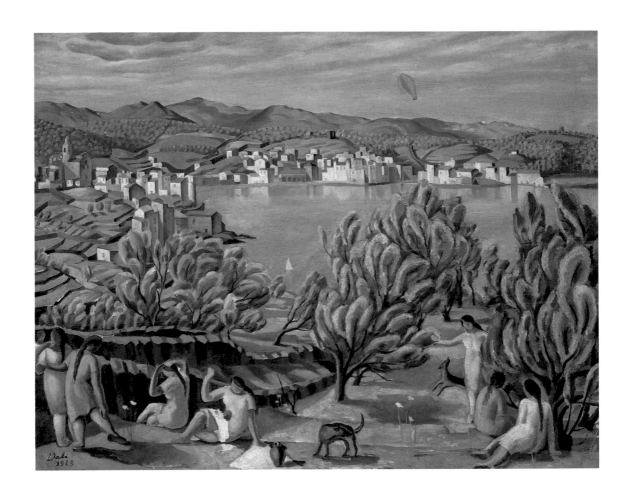

Cadaqués, 1923

desire for recognition was not merely of a superficial nature, for that desire had its own justification in Dalí's innate integrity and his willingness to pay meticulous attention to aspects which possibly would remain hidden from view. Nevertheless, the fascination of fame seems to have grabbed hold of him even before his artistic talent emerged; this talent in turn proved to be an excellent means of achieving fame. His sister reports that when Salvador, as a boy, once became tired on a family walk, the promise of sweets or the like could not move him to take another step; his aunt then simply had to put a paper hat on his head and announce that he was Napoleon for him instantly to take a stick between his knees and gallop away on this Pegasus (further spurred on by a drum roll, if need be), off up the steep path to the top.[5]

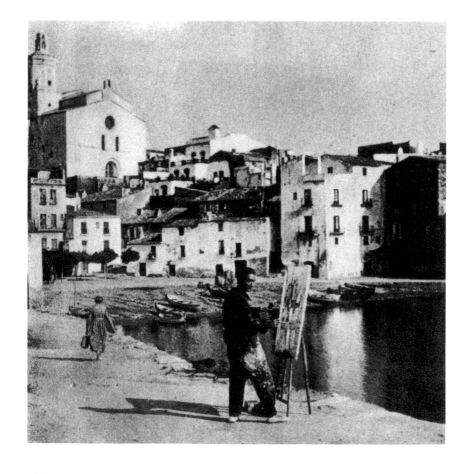

Dalí painting
Port Alguer in 1924,
photograph

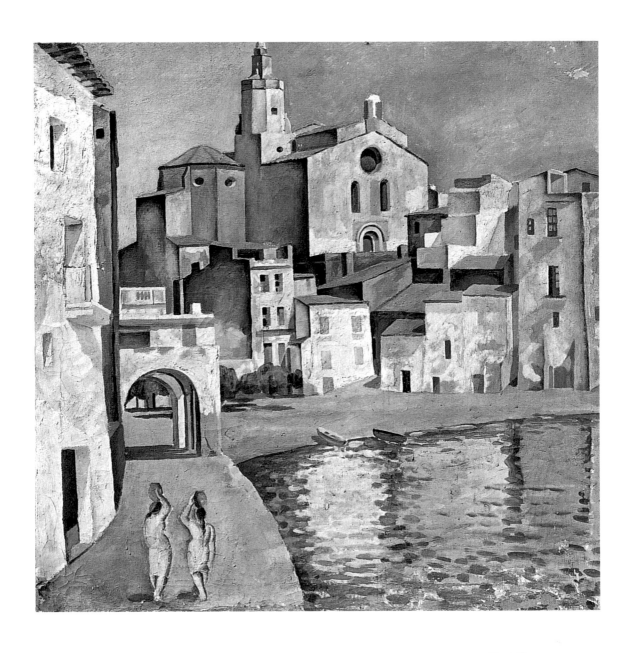

Port Alguer, 1923 – 24

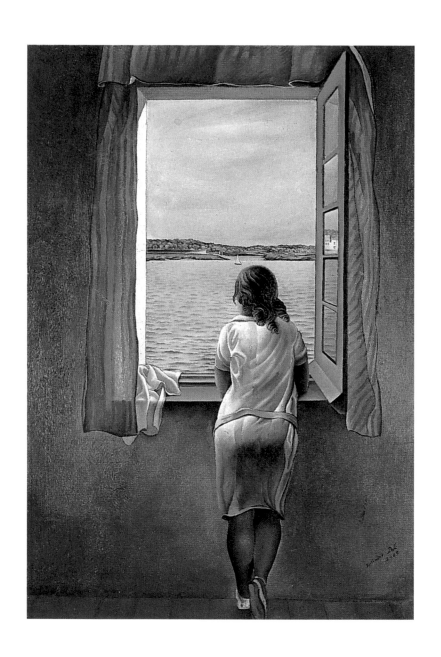

Young Girl Standing at a Window, 1925

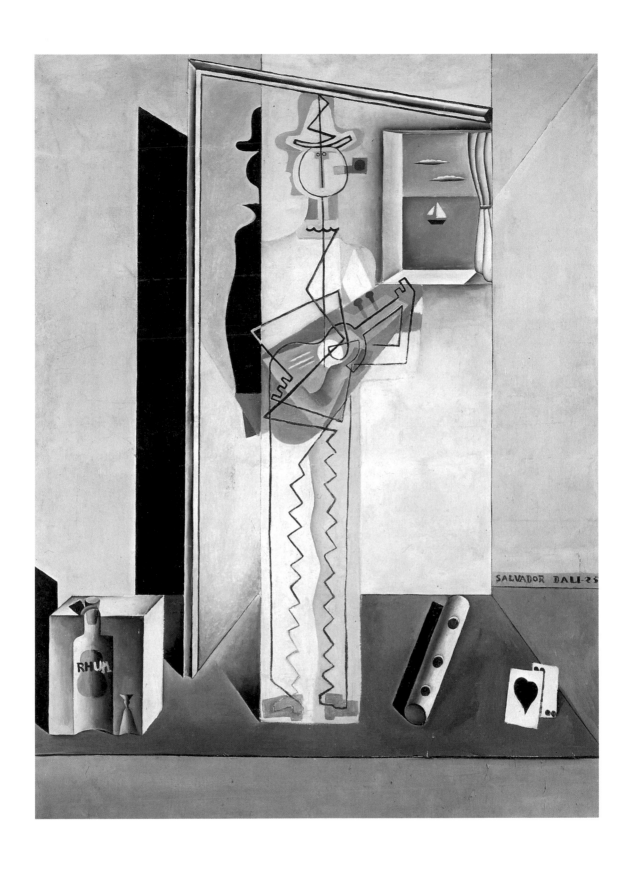

Large Harlequin and Small Bottle of Rum, 1925

In 1925 the contradictions in his styles became particularly stark. *Large Harlequin and Small Bottle of Rum* contains various experiments. The guitarist is portrayed as a skeletal stick-figure, while the bottle of rum and the up-turned glass are in three dimensions and seen in the negative. Writing from Cadaqués in the summer of 1925, Dalí told his friend Federico García Lorca that he was just then working on representing a "vacuum": he believed that "the plasticity of vacuums is very interesting, but so far no-one has paid any attention to this."[6] The asthenic figure of the harlequin, which resembles the "putrefactos" (the decaying figure type) that the artist was developing during that period, anticipated Calder's wire drawings and Picasso's *Statue from Nothing*. (It is possible that Dalí had seen the second issue of *La Révolution Surréaliste* from January 1925, which contained the filigree–like constellation drawings that Picasso had made as studies for the *Statue from Nothing*, a monument in memory of Apollinaire which is, in fact, an antenna for receiving signals from outer space.) But the painting also contains ideas from other artists: Le Corbusier, Morandi, Carrà, and de Chirico.

And then there is the *Young Girl Standing at a Window*, looking out over the bay with her back to the viewer. Anything but skeletal, her shapely body shows through the folds of her dress. Her pose is graceful, and her soft, organic form is all the more striking seen against the smooth, straight rectangle of the window. The flowing fabric plays round her figure and the wave motif of the sea is taken up by the curtains, the girl's hair, and the cloth on the windowsill. The context defines the meaning: in the twentieth century, a partiality for back views (a perspective more typical in paintings of the nineteenth century Romantic period), is interpreted in the context of psychoanalysis as suggestive of the anal phase and as the perspective of the voyeur who can see without being seen.

The richness of Dalí's oeuvre lies in the way that head and heart, geometry and colour work together. Detailed, sensitive depiction is paired with huge intellectual freedom, each raising the other to a higher level. Although precision is the dominant factor in *Basket of Bread* of 1926, the intensity of the bread's presence gives the object a surface tension, as though this crusty substance wanted to break out into some other state – as in physics where the tiniest of particles may release an explosion. The bread is on the point of becoming something greater than itself, something political, holy, transcendental...

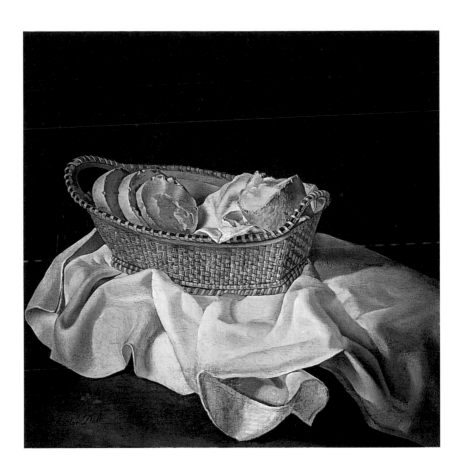

Basket of Bread, 1926

The *Basket of Bread*, which Dalí chose for his first participation in an exhibition in the United States (at the Carnegie Institute in Pittsburgh) is an early harbinger of the fame he is to achieve. Similar to Picasso during his Blue Period, Dalí acquired a solid basis of undeniable technical mastery as a young man, which naturally won him recognition as a great artist, even – and in particular – from people who were not part of the art world. This was to pay off later when his works clearly became much more demanding intellectually and either shocked or were simply too much for the public and critics alike. For the "conquest of bread" was to be followed by the "conquest of the irrational."

If we try to discover the reasons and the driving force behind Dalí's pursuit of greatness and fame, we come upon three "grievances" that these were supposed to make up for.

The Enigma of Desire, with its many inscriptions of "ma mère," indicates that his mother (mother: the "origin of the world," as Courbet said) is the mother of desire, which includes the desire for

fame. In Dalí's case, it was the sudden, early death of his mother on February 6, 1921 that motivated him to take revenge on Fate which had wrenched from him the one being who loved him unconditionally and forgave all his faults – or rather saw no faults, only strengths. In Dalí's own words: "I swore to myself that I would snatch my mother from death and destiny with the swords of light that some day would savagely gleam around my glorious name!"[7]

The second "grievance" derived from the fact that as a child he was exceedingly shy. Just as nowadays phobia-sufferers are sometimes instructed by their psychiatrists to confront the source of their fear directly – or as Goethe fought his fear of heights by climbing a mountain – so the twelve-year-old suddenly felt "a strange emotion" when a spontaneous, unusual act unexpectedly made him the centre of attention.[8] Having once made this discovery, he sought to repeat the experience and this quickly led to his mastering the skill for which he became renowned: of attracting attention, controlling his audiences' reactions, and playing with their expectations.

Dalí's birth was, in effect, his earliest experience of rejection. As soon as his consciousness awoke, he felt that he was no more than a replacement for his brother (also named Salvador) who had died

The Enigma of Desire, 1929, detail

The Enigma of Desire, 1929

nine months before his own birth at the age of 21 months. His later explanation of his brother's slender hold on life as the result of being conceived "too much in the absolute" is unusually modest for him. For here Dalí was without hubris, recognising that higher than him there was the absolute. A generous portion of egoistic greed appears to have been necessary for his survival, while at the same time, the huge intensity and energy of his art resonate to the sounds of his fight against scorn, shortcomings, and suffering. Out of fear of being someone else, he became himself.

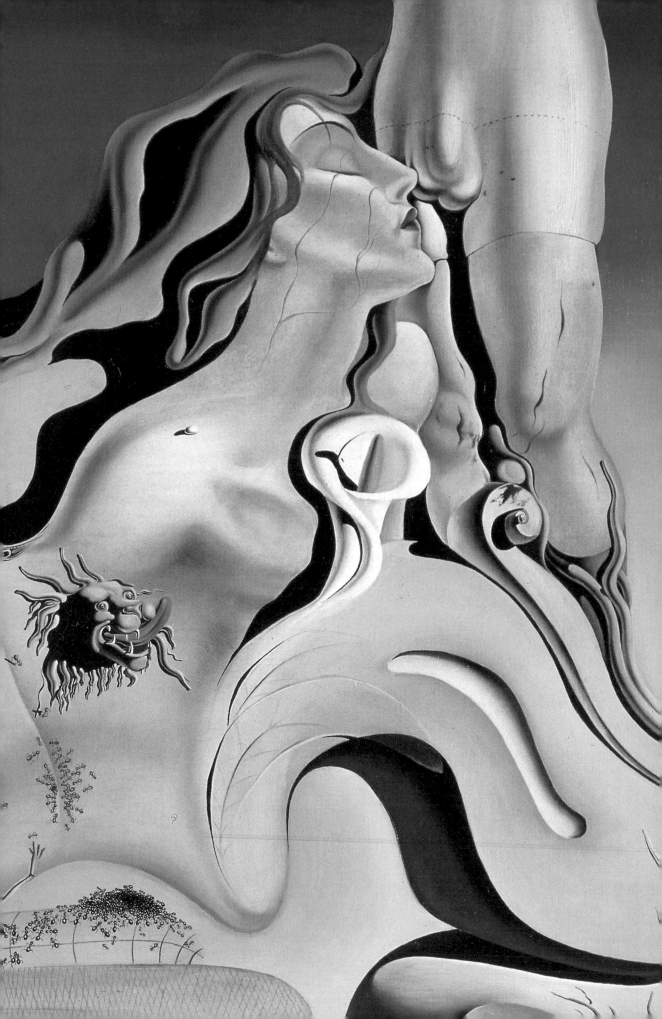

The Pleasure Principle

The Joys of Childhood

Long before turning into libido in the narrower sense, pleasure, in all its rich variety, played a leading part in Dalí's life. Its origins lay in his mother's womb. With characteristic originality, Dalí starts his auto-biography with his memories of an intra-uterine paradise. Pleasures there were optical, with his strongest memory being of "a pair of eggs fried in a pan, without the pan" – as though mirroring his own developing eyes. The frequent occurrence of floating eggs in his later works can be interpreted as an expression of his desire to return to the paradise that provided these pleasures.

Amongst the characteristics and tendencies that coloured his childhood, Dalí stresses his "natural tendencies to megalomania," his relishing his superior social status, the way he enjoyed domin-ating others – whether out of overwhelming love or out of anger, his sudden feelings of aggression, his thirst for revenge, jealousy, his urge to bite and grab, his wanting to be exceptional, his fear of the "practical principle of action," his receptivity to optical illusions, and his lively imagination that went hand in hand with his "tyrannic will."[9]

Particularly significant for his future were his leanings towards "mystification and simulation." But, at this early stage in his auto-biography, there is no evident connection between these and his painting, which does not, as yet, even receive a mention. The first form of artistic activity that Dalí refers to is writing: the seven-year-old discovers the "pleasure of writing properly" when he is given a notebook with silky paper.[10] Despite this, what he loves above all is to alternate abruptly between calligraphy and rough scrawls.

Painting is first mentioned, and then only en passant, in his descriptions of two scientific discoveries that he made at the age of nine: the phytomimesis of the stick insect, and the principle of the camera obscura. When his mother, who could read his every wish in his eyes, allowed him to take over a laundry room on the

The Great Masturbator,
1929, detail

roof of their house, he made it into a studio for himself, although from his description it would not seem that it was here that he began to paint. Instead, painting emerges, and is suddenly quite naturally referred to, as though this was something he had always done. The laundry room high up above Figueres merely provided the child with the opportunity to pursue this activity in more suitable surroundings, in solitude and freedom, high up above all others, if need be, on hot days, sitting waist–high in a tub of tepid water and giving free rein to his "limitless pride and ambition."

When Dalí says that he also created his first sculpture up there – a clay copy of the Venus de Milo – and that it gave him "an unmistakable and delightful erotic pleasure," it seems he is showing his agreement with Freud's comments on childhood sexuality: "One feature of the popular view of the sexual instinct is that it is absent in childhood and only awakens in the period of life described as puberty. This, however, is not merely a simple error but one that has had grave consequences, for it is mainly to this idea that we owe our present ignorance of the fundamental conditions of sexual life. A thorough study of the sexual manifestations of childhood would probably reveal the essential characters of the sexual instinct and would show us the course of its development and the way in which it is put together from various sources."[11] Among these sources Freud counted "certain 'instincts' (such as the scopophilic instinct and the instinct of cruelty) of which the origin is not yet completely intelligible." In addition, Freud characterized childhood sexuality as "essentially autoerotic." Indeed, Dalí does describe how he felt on the terrace outside the laundry room in very similar terms: "I was imbued with a fantastic and passionate tenderness toward myself."[12] But his instincts were already set towards cultural goals, although in fact, he seems to have experienced a constant to-and-fro between the sublime and the base physical. Freud suspected "that all the connecting pathways that lead from other functions to sexuality must also be traversable in the reverse direction."[13]

Dalí's subsequent experiments in painting at Molí de la Torre were accompanied by similarly pleasant sensations: the vertigo he felt when standing on the roof of the tower, the cooling and drying of hot *café au lait* poured on his skin, the delight of burying his naked body under grains of corn, and the enjoyment of an exhibitionistic ritual when his nanny would come into his room in the morning to

find him "sleeping" with the bedcovers flung aside. The picture sur-
face for his *trompe l'oeil* cherries was a worm–eaten old kitchen door.
The real worm-holes looked as though they were in the painted
cherries. But the real cherries that he was painting from also had
worm-holes in them, which gave him an "unbelievably refined" idea
– clearly related to Freud's concept of a two-way path between
sexuality and sublimation, body and spirit: "with a limitless patience,
I began the minute operation (with the aid of a hairpin which I used
as tweezers) of picking the worms out of the door – that is to say, the
worms of the painted cherries – and putting them into the holes of
the true cherries and vice versa."[14]

At the time when he discovered masturbation, later than his
classmates did, by the way, his interest in philosophy also awakened.
He was, as well, working with intense concentration on refining his
drawing technique. "'It' finally happened to me one evening in the
outhouse of the institute [his secondary school]; I was disappointed,
and a violent guilt feeling immediately followed."[15] Since Dalí, in his
description of intra-uterine paradise refers to Otto Rank's *Trauma of
Birth* (first published in 1924), another work by this author deserves
mention, in which Rank talks of the "feelings of guilt and self-
reproach that cast the gratification achieved through masturbation
in a reprehensible light." The "obvious signs of shyness" are discus-
sed, "the diffidence in social situations and the tendency towards
blushing all displayed by those who masturbate … stemming from
their sense of guilt and their own auto-erotic sexual life that barely
leaves any libido available for establishing a positive emotional rel-
ationship with the outside world."[16] All of this would seem to cor-
respond to Dalí's own description of himself: "I was at this time
extremely timid, and the slightest attention made me blush to the
ears; I spent my time hiding and remained solitary."[17] Soon, however,
art enables him to overcome this embarrassing condition. After all, it
is hard to imagine less timid, less guilt-ridden behaviour than paint-
ing and exhibiting a work like *The Great Masturbator.*

It shows a huge yellow face (when it was first shown it was still
called *The Face of the Great Masturbator*) with a bird-like, flattened
forehead and a large nose, pink–tinged cheeks, and a closed, long-
lashed eye. The mouth is not simply closed, it is not there at all,
covered over with skin, paralysed by fear of the grasshopper clinging
there, which in turn is under threat from the ants swarming over its

stomach. From the nape of the neck of the bizarrely formed head, which has a cluster of stones and shells balancing on it, a beautiful woman emerges, also with closed eyes. While the form lying nose-downwards on the landscape might have been inspired by one of the enigmatic rocks on the beach at Cadaqués – or by a whale once stranded there,[18] the flowing Art Nouveau forms on the right hand side of the picture go back to a fun-fair photograph showing a woman smelling a lily.[19] The erotic connotations of calla lilies with their thick spadices – as depicted by Georgia O'Keeffe a year earlier – are underlined by Dalí's moving this lily downwards to the right and replacing it with the lower body of an athlete in tightly fitting train-ing shorts. Blue veins, running through what is both body and stone, contrast with red traces of blood, the red of the woman's mouth and the red of the lion's tongue in the centre of the large head. This lion, licking its lips, with its tangled mane and wide open eyes is the only element of movement in the otherwise dreamlike stillness of the scene. It is a potent symbol of the desire which invokes the virtual reality of the masturbator's world.

Georgia O'Keeffe,
Two Calla Lillies in Pink, 1928

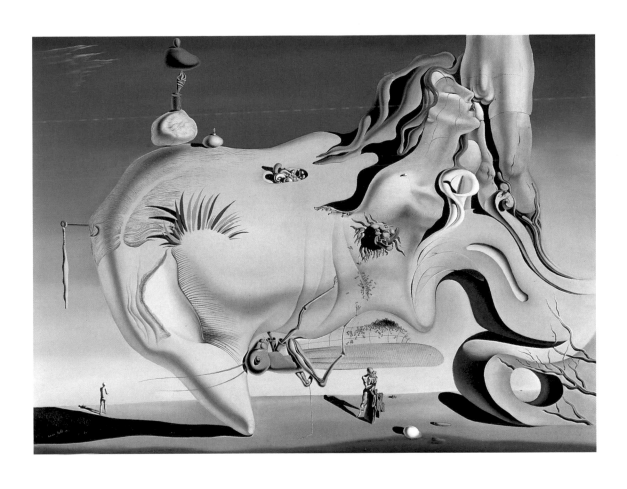

The Great Masturbator, 1929

There is an interesting theoretical question: to what extent is sexual activity compatible with artistic achievement, necessary for it, or detrimental to it? Answers veer wildly between two extremes, which could be called the Kant-hypothesis and the Simenon-hypothesis. While Immanuel Kant's philosophical works seem to be entirely at one with his own asexuality, perhaps even a result of it, the output of the Belgian detective story author Georges Simenon seems to be equally at one with his insatiable sexual appetite. Leaving aside the difficulty of in any way checking the facts, obscured by modesty or exaggerated by boasting as they may be, it is nevertheless fair to say that of the two, remarkable as they both are, in the end Kant's work proves to be not only intellectually more demanding, it is spiritually of greater significance.

Freud also tended in this direction, saying that "Science is, after all, the most complete renunciation of the pleasure principle of which our mental activity is capable."[20] This does beg the question, however, as to whether in this context Dalí, who had boundless respect for Freud, saw his art as being as close to science as his pronounced interest in the visual assimilation of scientific findings would in fact suggest.

Dalí made two experiments using his own person. A comparison of the results would show whether the Kant-hypothesis or the Simenon–hypothesis was true. On the one hand there was *The Great Masturbator*, a distanced and fully thought–out representation of sexual experience which had come into being during a month of monastic solitude after his first meeting with Gala. On the other hand, there is the Dalí illustration for Georges Hugnet's book *Onan* which takes the notion of the mutual intensification of sexual and artistic activity to its ultimate extreme. As though in a satirical prefiguration of Cy Twombly, Dalí signs his work as a "'Spasmo-graphism,' carried out with my left hand while I masturbate with my right hand until I draw blood, right down to the bone, to the helix of the chalice."

It is clear that Dalí is much sooner a man of reflection than of reflexes – notwithstanding his familiarity with these. In later years he describes his own point of view: "Every creative person ... fundamentally experiences a certain degree of abstinence.... Physio-

logical expenditure is an immediate means of relief. … Accumulated frustration leads to what Freud calls the process of sublimation. Anything that doesn't take place erotically sublimates itself in the work of art."[21] Unlike Nietzsche, who saw Raphael as a powerful animal being *(Krafttier)* and saw the only explanation for his beautiful Madonnas in a "certain over-heating of his sexual processes," Dalí considered him to have been "practically impotent." The two approaches meet in an acceptance of the idea that unfulfilled sexual desires can be converted into artistic energy. Any scientific examination of the true facts of the matter would depend upon reliable data on

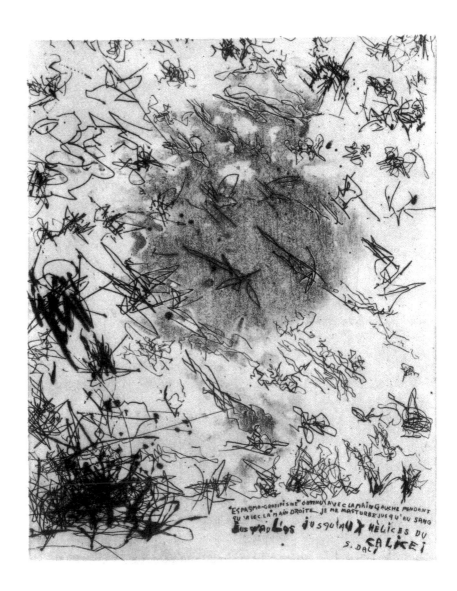

Illustration to
Georges Hugnet's
book *Onan,* 1934

33

the existence of such desires and their gratification – data that is scarcely obtainable, particularly if the subjects in question died long ago.

But we are hurrying ahead of ourselves. Dalí's presentation of sexual matters had not always been so distanced, reflective and explicit – his sensitivity in this area only developed and crystallised over the years.

An early example of his susceptibility to the erotic is to be found in his *Bathers of Es Llaner* of 1923 (p. 16) which explores a whole range of the graceful forms and movements of female figures bathing – although these could also be the multiple images of one single bather. A preference for full shapes, reminiscent of Léger and of Picasso the classicist, is coupled with molecular vibrancy which lends the whole an air of tingling excitement, with a sensual appeal that is both optic and haptic. (This same impulse towards synaesthesia later gave Dalí the idea of tactile cinema. Every time a female breast, for instance, is shown on the screen, a plastic model of the breast appears in front of each viewer, inviting him to touch it.)

This type of light–hearted vision of paradise appears for a while longer but only until it is subjected to the pressure of painful analysis. The year 1927 marks a sharp break in Dalí's work. It is the period after his abrupt departure from art school; it is the time of his military service, of his friendships with Lorca and Buñuel, of his first forays into Surrealism. *Apparatus and Hand* is the title of one picture. A Pavlovian nerve-bundle rises up from a concrete platform set in the Mediterranean. It is precariously balanced on stilts, already crying out, as it were, for one of the crutches so often present in Dalí's later works. A wonderful blue sky arches above it, but it is in the grip of a Turneresque whirlwind and strange things are circling around: small, spirit–like beings resembling genies released from bottles, breasts, birds or flies, a donkey that has choked on a bone, and a well-proportioned female torso.

The same thematic material is the subject of the strangely named painting *Cenicetas*. It is weightier than *Apparatus and Hand* and more open in its composition. It includes dismembered and relocated elements and several veined heads and torsos; one resembles a *madonna lactans*, from out of another particularly three-dimensional form in rear view pour streams of blood. The large body balancing on the left in front of the sky is covered in feather-down with guitars,

34

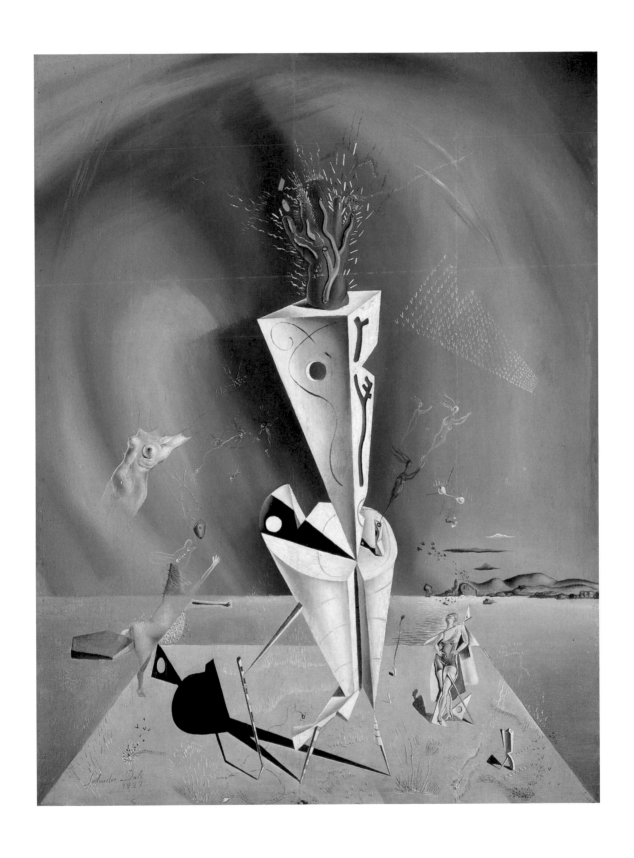

Apparatus and Hand, 1927

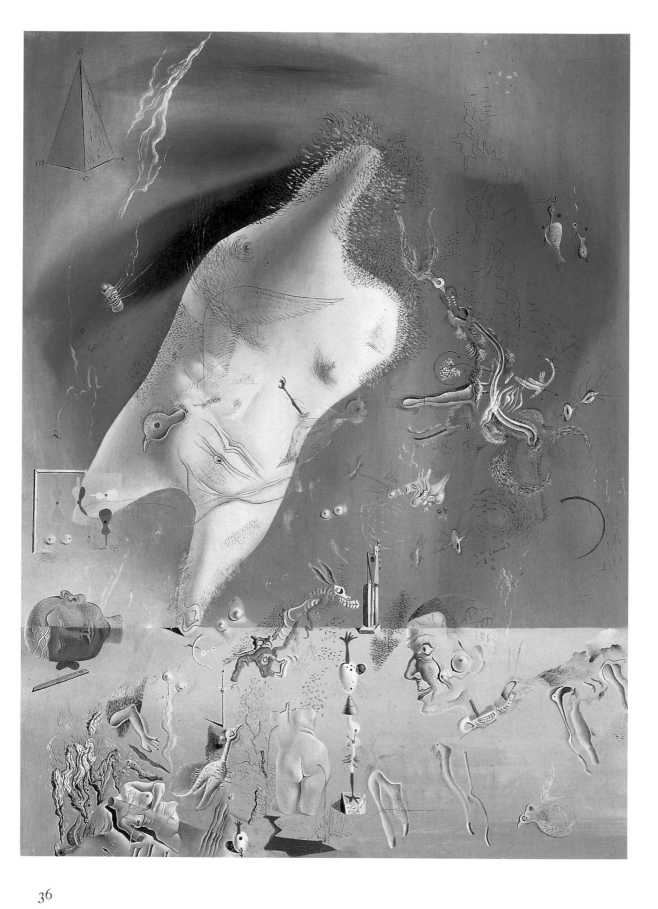

breasts and phallus–like fingers swirling around it. A cheerfully rotting donkey looks at the "apparatus" which has now retreated into the distance, undeniably suggesting its metaphysical origins while, in the upper left corner, a geometric form from a text-book prevents the otherwise organic forms from dominating the picture.

In *Ungratified Desires*, besides oil on cardboard, Dalí used sand and shells: particles of real matter that relate to the subject matter of the picture, because the gratification of a desire is also its realization. The desire in question here is very clearly of a sexual nature. On the left we see a hermaphroditic combination of male and female sexual organs and a hand. On the right there is a flesh-coloured torso with a small red flag making a notch in its knee. The scene is reminiscent of Buñuel's experience of dreams: "in them I've never been able to make love in a truly satisfying way.... sometimes, when the climactic moment arrives, I find the woman sewn up tight. Sometimes I can't find the opening at all; she has the seamless body of a statue."[22]

Ungratified Desires, 1928

Facing Page:
Cenicitas, 1928

Overleaf:
The First Days of Spring, 1929, detail

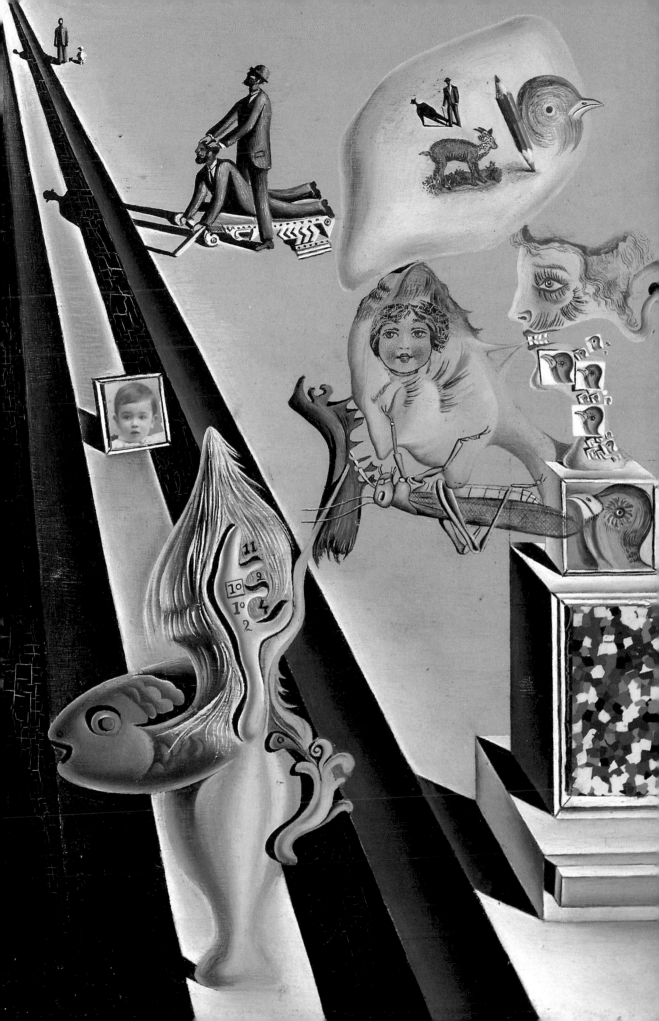

Nor had Dalí at that time (in a waking state) ever slept with a woman. The as yet thwarted fulfilment of desire is in some degree compensated for by the reality of the sand in his painting. Even if the picture initially had the less explicit title of *Figures on a Beach*, its allusions were perfectly clear to Dalí's contemporaries. Dalí had submitted it in October 1928 as one of two works for the autumn salon in Barcelona but the director, however well-disposed towards him, asked to be spared from showing this work because its effect on the public would have been to "disgust them to the very core of their being."[23] Faced with the choice of showing either one work or none at all, Dalí accepted the compromise but took the opportunity of a lecture to make up the missing element of provocation.

This picture was also excluded from his first Parisian solo exhibition at the end of 1929, but this was more than offset by the inclusion of others: *Cenicitas*, still known then by the simpler title *Futile Attempts*, and *The First Days of Spring* from early 1929, showing "libidinous pleasure... described in symbols of a surprising objectivity."[24] This refers to the figures left of centre in the foreground. A gagged man is washing his hands in all innocence as, kneeling, he leans against his wife's shoulder. She sits confidently facing the viewer, but her head has been replaced by some kind of carnivorous plant with a swarm of flies at its opening. Her breasts, arms, and thighs appear to phosphoresce. Her clothing is unconventional and seems to be saying: Never was a man's neck-tie less of a phallic symbol.

On the other side, on a high plateau, Dalí painted his "favourite" phobia: the grasshopper that he has associated since early childhood with a slimy little fish.[25] Next to it, a photograph of the artist as a child confirms the autobiographical aspect of this work. The lines of the shadows fleeing into depth – a narrow path between the higher and lower levels – perhaps stand for the life of Dalí thus far who, in the distance, makes his first attempts to walk but now finds himself in the first days of spring. Other figures, such as the somnambulists who seem to be playing "wheelbarrow," are perplexing. The dapper gentleman in the brown suit is perhaps Sigmund Freud, the young girl may be wanting to entrust him with her subconscious, but he is replying: "You hold on to it. We'll come back to it later." And then there are more pictures within this picture: a relaxed group of worldly individuals on a ship, and a light–box on the right filled with

the hissing noise of a multi-coloured snow storm, a fascinating herald of colour television. On it there is a smaller box projecting the image of a bright parrot-like bird with an eye like a parasol, an image that is taken up again one level higher.

In *Illumined Pleasures*, the screens are not hissing any more, but are receiving various programmes, ranging from black and white through to colour. At several points, levels of reality merge into each other, for example, the blue which can be taken as both sky and water. They seem to represent the various stages of an individual's sexual life: the cracking egg-shell would be the intra-uterine phase and the trauma of birth; in the centre would be the loneliness of the masturbator who is watching himself, as can be seen in the naked youth to the right, standing in a pose that belies both voyeurism and shame. This same youth returns in other paintings, as in *Solitude*.

The First Days of Spring, 1929

The shells symbolise Nature as reflective and withdrawn. (Dalí liked the way Heraclitus put this: "Nature loves to hide.") On the right-hand screen there is an army of bearded men dressed in grey riding and riding bicycles. It is an image of precarious, dreamlike equilibrium, for not only does each man have a stone balanced on his head; the men are also riding in opposite directions without colliding into each other. Whereas this image shows energy converted into uniform movement, in the scene closest to the viewer the impulse is towards violence. An elderly man, also wearing a grey suit, importunately grasps a terrified woman who stretches out her blood-stained hands, apparently wanting to wash them in a wave from the sea. Her hands correspond to the three-dimensional emblem of two hands, left of centre at the front. One of the hands holds a blood-smeared dagger; the other clutches at the wrist of the first, attempting, clearly in vain, to intervene like the angel of the Lord – as in Brunelleschi's bronze relief – preventing Isaac from being sacrificed.

Illumined Pleasures,
1929

42

What this scene might be referring to remains a mystery: the man could be Dalí's father, but who is the woman – his daughter, his wife, or his wife's sister Tieta? For the fact is that Dalí's father married Tieta shortly after the death of his wife. His mother was without equal in Dalí's eyes and this kind of "substitution" must have cut through him like a knife.[26] Whatever the case, the connection between wrong-doing and pleasure is reinforced by the way that the picture, nakedly violent at the lower level, is crowned by a bizarre vase, a vessel of desire, an amalgam of the lion – already familiar from *The Great Masturbator* – and two women with handles instead of ears.

Solitude, 1931

The Accommodations of Desires tames the lion. Dalí reports that he began to paint the picture exactly at the time when he met Gala, that is to say, at the beginning of September 1929.[27] And the "accommodations" are a reconciliation of the pleasure principle with what could be called the reality principle. Desires lose their terror, the lion – analysed and examined as a graphic structure – is unmasked as a paper tiger. Dalí felt that meeting Gala had healed him of his neuroses, his anxieties, and his aggressive urges. His attacks of hysteria disappeared because he now had another outlet. "It is therefore not without cause that the state of being in love, which can go as far as identifying the whole outer world with the object of affection (Wagner's *Tristan and Isolde*) has been described as a neurotic introversion, and coitus with its momentary loss of consciousness as a slight hysterical attack" (Otto Rank, *The Trauma of Birth*). But Gala also intensified one conflict – between Dalí and his father, most likely seen here as the bearded figure of the group in the background of the picture.

Later on Dalí's father often emerges in the figure of William Tell. The analogy lies in the famous scene with the apple where Tell endangers his son's life. Dalí felt himself similarly threatened by his father who threw him out of the house on learning of his relationship with Gala (still married to Paul Eluard at the time), and was outraged by the shocking influence of his son's new friends, the Surrealists. At the same time, Tell murdering the tyrant Gessler is also Dalí himself defying his father. Thus Tell is an ambivalent figure. Otto Rank saw him as embodying "the displacement of emphasis": "Here the father aims at the son, but the way Gessler, for whom the second arrow is meant, forces Tell to do so marks him as a 'father' with respect to Tell." Rank interprets the murder of the tyrant as an expression of "Schiller's father hatred" and views *William Tell* as an incest drama focusing on the father complex with Tell's deed as "patricide in disguise."[28]

The real ambivalence of the figure of Tell can be seen in the extraordinary painting *William Tell and Gradiva*. Since Gradiva is Gala, and if Tell is to be identified as Dalí's father, Dalí could be suggesting that his father's rejection of Gala is because he secretly desires her and is envious of his own son. Since this desire is beyond the father's

reach, it is displaced and transferred into jealousy in the same way that the actual aim of the sexual drive, the union of the sexual parts, is substituted here by a simulation involving a hand and an arm-pit. On the other hand, this could be the artist's portrayal of himself, in an idealized form, shortly before the "juicy grape-harvest of our passion" on Dalí's first decisive walk with Gala along the cliffs of Cadaqués. (As Freud first established in *The Interpretation of Dreams,* the identification of the son with the father is an important part of the Oedipus complex.)

Glowing lava, some might see it as grapes, appears to fill Tell's scrotum, while Gradiva's nipples are almost caricatured, standing out like babies' soothers or teats. Both themes, fluid geology and the joys of the infant, coalescing here (in a small format) as hallucinogenic presences, are already evident on the larger canvas *The Enigma of Desire* (p. 25), yet not as clearly. This work which was shown with the title *The Picture of Desire* in Dalí's first exhibition (beginning on November 29, 1929), seems to have been painted in October 1929 in Figueres, after Gala had left, as the second of "two large canvases,

one of which was to become famous."[29] The latter is *The Great Masturbator* (p. 31) which has exactly the same dimensions.

Between the small head of the masturbator, lying face down on the ground, and the lion's head in the upper right–hand corner, the anxiety-laden conglomeration of desire and of a father poised for violence[30], there is a "womb" (in Spanish and French "womb" can also be a technical term for a hollow form) consisting of a mass of "holes." About half of the hollowed out pictorial fields contain the words "ma mère," which simultaneously relate to a verse by the Dadaist poet Tristan Tzara, to Magritte's word pictures from the same period, and to Dalí's own reluctance to portray his mother as a visual image. Through one of the holes, far away on the plain, the viewer can see a perforated rock which in turn reveals a naked and wounded female torso. This glimpse of a female body recalls a childhood memory of Dalí's going back to when he saw a beautiful woman picking blossoms, similarly obscured by the frame of a window.[31]

What had been a child's erotic ideal, became reality in Gala. *The Enigma of Desire* marked the point when his love for his mother had to give way to his love for a woman. Dalí emphasized this change – although, or perhaps because, he knew that young men are unmistakably influenced in their choice of a woman by the example of their own mothers.[32] But he emphasized it in an unpleasantly provocative manner: one of his works exhibited in Paris shows the sacred heart with a lovingly painted inscription that translates as "Sometimes for fun I spit on the portrait of my mother." Later on he attempted to mitigate this invective, half helplessly and half cynically, explaining that, in some religions, spitting was a symbol of respect. It was probably intended to facilitate Dalí's entry into the circle of Surrealists who flatly rejected all family and religious values. His father reacted immediately when he learnt of this from the press and forbade his son ever to come to Figueres or Cadaqués again. It could be that Dalí's father reacted so strongly because, subconsciously, he sensed in the work a possible reference to his own behaviour towards his late wife.

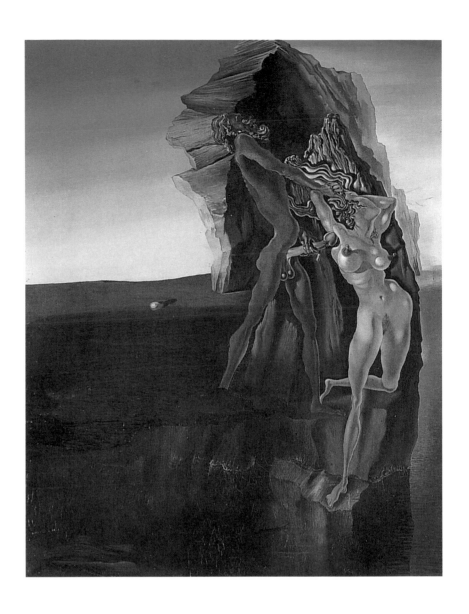

William Tell and Gradiva, 1931

Erotic Drawing, 1931

Dalí called Gala "Gradiva," and this needs some explanation. *Gradiva: A Fantasy Tale from Pompeii* was the title of a novella published in 1903 by Wilhelm Jensen. It is about an archaeologist, Norbert Hanold, whose work has made him lose touch with life, and who is fascinated by an ancient stone relief showing a girl walking gracefully along. Hanold calls the girl "Gradiva" ("the girl who steps along") and tries to find someone with the same gait in real life, but in vain. Then, as the result of a dream, he becomes convinced that Gradiva lived in Pompeii at the time of the eruption of Vesuvius. Without quite realising what his motivation must be, he soon sets off on a scientific research trip to Italy, which finally takes him to Pompeii. Once there, he senses an ability he had never felt before in his dry, scholarly existence to "animate" the past. Suddenly he "sees" his stone Gradiva crossing the street. When he talks to her she answers in German, which throws him into confusion over whether she is real or not. This uncertainty lasts a bit longer until in the end it becomes clear that "Gradiva" is in reality a young woman from his own neighbourhood. Her name is Zoë Bertgang and in fact they were friends as children – a friendship now being dug free from under the ashes. Suddenly it hits Hanold that "'Bertgang' means the same as 'Gradiva' and describes someone 'who steps along brilliantly.'" In the end Hanold, having found his Gradiva, asks her to cross one of the streets of Pompeii in front of him: "and, pulling up her dress a little with her left hand, Gradiva *rediviva*, Zoë Bertgang walked past … with her quietly tripping gait, she stepped through the sunlight over the stepping-stones to the other side of the street."

It had been C.G. Jung who had drawn Freud's attention to this novella and in 1906 – 07 Freud produced a lengthy study of it entitled "Delusions and Dreams in Jensen's *Gradiva*." What attracted him was the idea of applying the methods of his *Interpretation of Dreams* to dreams that had not really been dreamt but which had been told by a fictional character in a work of literature. This would of course also require an analysis of the characters involved and of the story in which they appear. Jensen's choice of an archaeologist as his protagonist and Pompeii as the setting for the action led Freud to his analogy between the burial of Pompeii by the eruption of Vesuvius and "repression, by which something in the mind is at once made in-

Drawing from
*The Secret Life of
Salvador Dalí*

accessible and preserved." The parallel here is all the more meaning-
ful since what Jensen's character Hanold represses is a the memory
of a childhood friendship, and the burial of Pompeii was an event
during the childhood of our civilization. Freud saw Jensen's novella
as a psychiatric case study, "a case history and the history of a cure."
He in fact describes Hanold's case as an "ideal one" since Gradiva is
"able to return the love which was making its way from the uncon-
scious into consciousness, but the doctor cannot."[33]

When Dalí read Jensen's book – even before coming upon
Freud's interpretation[34] – he cried out, "Gala, my wife, is essentially
a Gradiva." The similarities between the two come, firstly, from the
fact that Gala cured him of his mad hysterical fantasies and sec-
ondly, that he saw her as the reincarnation of a childhood friend –
although here Dalí did distinguish clearly between his "false" and
"true" childhood memories, at the same time taking into account
Jensen and Freud's subtly handled, multiple layers of reality. Just as
Freud, referring to the as yet unidentified vision of the figure striding
through Pompeii, talks of the "reality of a rediviva"[35] so, for Dalí,
Gala is a "Galuchka rediviva," that is, the reincarnation of a hyp-
nagogic image of a little Russian girl. This girl then became flesh and
blood for Dalí in the form of Dullita, a girl from Figueres, before
later turning into a twelve–year–old girl who helped with the linden

blossom picking, "so that the three images of my delirium mingled in the indestructible amalgam of a single and unique love-being."[36] There was a third similarity in their gait: Dalí saw Galuchka approaching but it is Gala who is walking in front of him, as a goddess of victory. The French "celle qui avance" (she who advances) strengthens the traditionally military connotations of the name Gradiva: Gala has become a member of the avant-garde with the battle cry "forwards" on her lips. In fact Dalí, for all his sensitivity towards art, was so anxious and inept in everyday life that he would surely never have had such success without his wife, who brushed any obstacles aside and organized all the necessities of their day–to–day existence.

But Dalí does not leave it at using hindsight to find similarities. He has an encore ready in which he sets out single-handedly to outdo Jensen and Freud by telling a fairy-tale of his own ("The Manikin with the Sugar Nose") and following it with a psychoanalytic interpretation. The kingly hero, ("a probably cannibalistic copro-necrophile") who is cured of his perversions by the clever Gala-Gradiva, is Dalí himself.

The following period saw the various stages of his work on an ultimately unfinished painting, *The Invisible Man*. The title designates it as a companion piece to his book *La Femme Visible* (*The Visible Woman*), published in Paris in 1930. The man is "invisible" because he consists of things which are not "him," but which he is hiding behind or standing in front of. His hair is made of clouds, his forehead is a kneeling woman, his eyes are large balls on a plain, one shoulder and an arm are a female nude seen from behind, and we can make out his hands as the spaces between the arms of a strange kind of candelabra which is also reminiscent of ovaries, fallopian tubes, and a uterus. If one considers the twin female figures floating on the right with the bleeding roses on their stomachs, there seems to be a connection with an operation that Gala would have to undergo at the end of 1931: the doctors had discovered a tumour in her womb, which they then removed entirely. Dalí's choice of the word "Stériliser," the heading for the text in the catalogue for his Paris exhibition of 1929, was, in fact, a macabre portent for what was to come.

Other than in a physical sense, the man is "invisible" as an allegory for Dalí himself – often "invisible" and behind the scenes in everyday life, protected and nurtured by the strong, more practic-

The Invisible Man,
1929 – 32

50

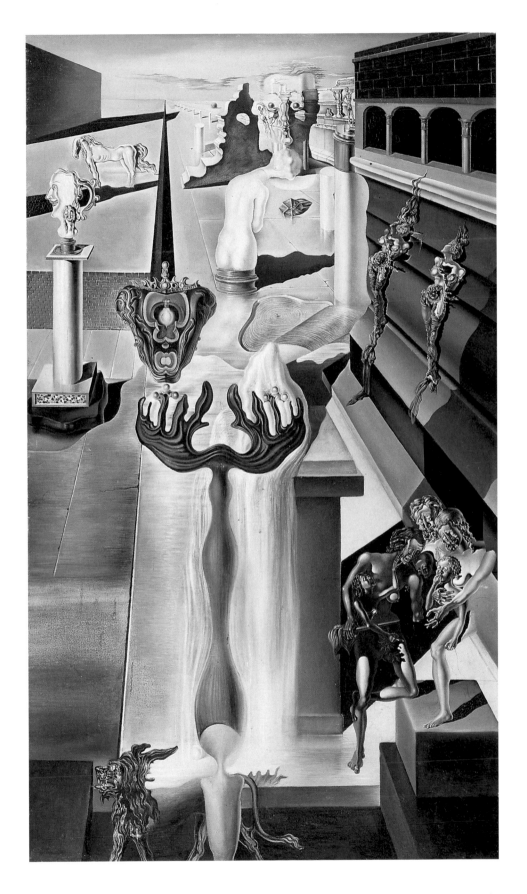

51

ally–minded Gala, his Gradiva who stepped along before him. Her influence was "visible" again when she put Dalí's explosive writings into syntactic and orthographic order; this would become the book *La Femme Visible*, which was named after her. In this book the author explains the double image depicted in *The Invisible Man* for the first time. It is a variant on paranoid thinking,[38] on the pleasure principle and on love.

The book also contains the heliograph of an ink drawing which – altered and incomplete – served as a model for the group in the right foreground in *The Invisible Man*. If one identifies the man as William

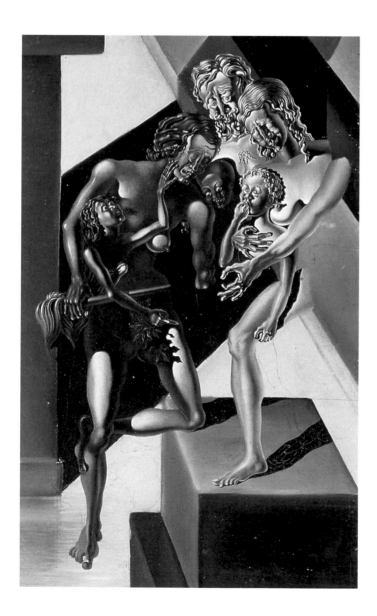

*The
Invisible
Man,
1929 – 32,
detail*

The Butterfly Hunt,
Illustration for
La Femme Visible,
published in 1930

Tell and thus Dalí's father, then the women he is laying his hands on could be Dalí's mother and her sister Tieta, with the artist himself standing next to his mother, the brother that died in the centre, and Ana María to the left being held by her aunt. The latter is holding a butterfly net which Dalí's mother is gently touching. A multiplicity of telling gestures point feverishly this way and that (the hand of the mother holding her son is corrected in the painting); only the butterfly remains invisible. Dalí had the unlikely capacity, found elsewhere perhaps only in Leonardo da Vinci, of being delicate and coarse, mysterious and blatant, all at one and the same time.

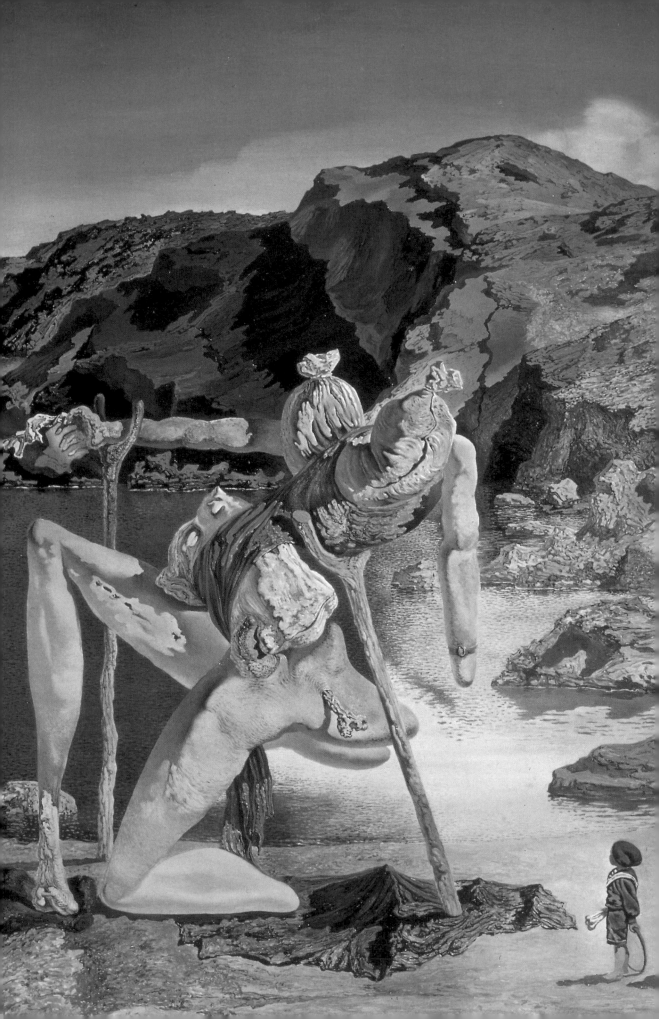

The Death Wish

The small painting, *The Spectre of Sex-Appeal*, is a sarcastic image of sexuality. The headless figure is in the advanced stages of decay, miraculously remaining upright with the aid of two crutches. Its chest and stomach have been replaced by sacks, tied to conceal their contents. The small boy in a sailor suit standing in the foreground – most likely Dalí himself – must at best be doubting the attractiveness of this puzzling phenomenon with rotting flesh and whose bones will soon become part of the stony landscape. Since his father kept a book on sexually transmitted diseases pointedly lying about at home, Dalí associated sexuality with fear from an early age.

Even before his trip to the United States at the end of 1934, Dalí sensed the trends that would be coming from there. This particular painting was shown in the Julien Levy Gallery in New York in an exhibition beginning on November 21, 1934. In France Dalí was among the very first to use the term "sex-appeal" (documented use in the USA goes back to 1924). At the same time, the French writer Jean Guéhenno was writing in *A Man of Forty* that he had seen the masses "marching past lovely Adolf. He is supposed to have tremendous sex-appeal, standing there with his ludicrous moustache."

Interestingly enough, Dalí also saw feminine traits in Hitler; he seemed like a woman to him. He was struck by Hitler's ridiculous fetish for uniforms and boots, and the way that the material of his uniform jacket was tight across his fleshy back, with leather straps cutting into his fat. So he portrayed him as a corpulent nurse sitting on the floor – once even in a puddle – with her fleshy back towards the viewer.

André Breton's response was remarkable. Instead of bursting into peals of laughter at its mockery – if any one of Dalí's paintings had hung in a German art gallery, it would of course instantly have been confiscated as "degenerate" and its creator would have been arrested – instead of analysing the psychopathological reasons underlying the strange fascination of this barbaric, deeply stupid

The Spectre of Sex-Appeal, 1934

regime (which would soon have led him to conclude that this was a matter of sexual repression and its transference into sexual perversion), Breton, a humourless, sullen ideologist, called a special meeting of Surrealists in order to discuss Dalí's apparent support for Hitler. When Dalí subjected Lenin to similar treatment (in *The Enigma of William Tell*, 1934), Breton saw it as defamation. The ideologist only had political ideas, but not logic, and most certainly not art on his side.

Just as, for Dalí, every William Tell is not Lenin, so every nurse is not Hitler. Thus the figure sitting on the pebble beach at Cadaqués in the 1934 painting *The Weaning of Furniture Nutrition* is probably inspired by Dalí's childhood nanny Llucia. In her torso there is a gaping hole the size of the bedside-table standing in front of her, which in turn has a hole the size of a second, smaller bedside-table. The nanny's astonishingly modern-looking gym shoes have no laces. The weaning is a reversal of the way that here bodily mass is replaced by nothingness. (Dalí had already taken up this theme in 1925, see p. 20) "Furniture Nutrition" means the mixing of carpentry and flesh, as also in the corporeal drawers, a motif seen in Dalí's works from 1934 onwards. Llucia, who was enormously tall and looked "like a pope" also appears in the form of an equally portly nurse or nanny in Dalí's "false childhood memories," as a "parapet of my desire" behind whose back the boy sought refuge from Galuchka's glances. But these glances were so penetrating that a window opened up in the nanny's back.[39]

Despite surgical fat-removal, the nanny herself remains an incarnation of the well-fed – particularly in comparison with the care-worn figures in Grant Wood's *American Gothic*, whose spindly pitch-forks contrast strikingly with Dalí's stout crutch.

In the mid '30s, paradoxically enough, just when his fame was taking an unshakeable hold internationally and the lean years of financial stringency were over, the artist was overcome by an undefined sense of anxiety – something unnerving was forcing its way into his consciousness: death. The Mephistophelean "headlong haste" of libido is suddenly confronted with the death wish. The horse stops. *The Horseman of Death* stretches his hand out commandingly. The picture displays a masterly synthesis of beauty and decay. The horse's flesh is suddenly falling from its bones, which have virtually turned to stone, returning to the inorganic. Its mane

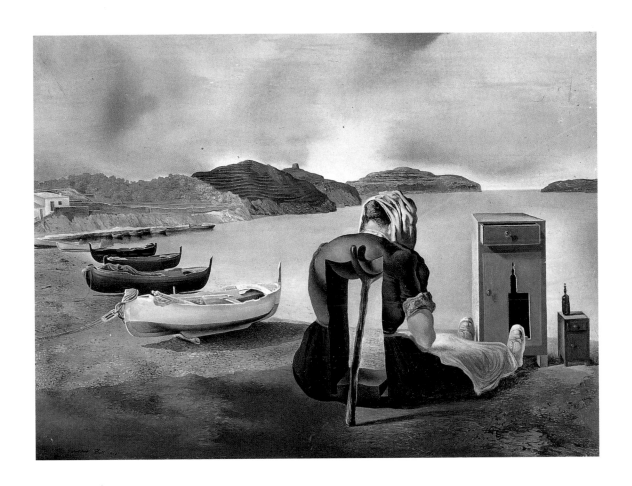

and tail are just as luxuriant as they ever were and both the body and neck of the horse and the skeleton of the rider are caught in an iridescent phosphorescent light. We sense a slight, meditative pause set dramatically in front of ghostly Böcklinian cypress cliffs and a De Chirico–style tower complete with a limp flag.

This work reflects not just a purely private concern with death, but also the political situation as a whole. The Spanish Civil War was threatening on the horizon, with the Second World War at some as yet indefinite point in the future.

In the history of ideas, the notion of a death wish first appeared somewhat earlier than this. Freud coined the term in 1920 in *Beyond the Pleasure Principle*, but he was not at all comfortable with it, only managing to describe the phenomenon, to his dissatisfaction, as an ego-instinct opposing the sexual instinct. In *Civilisation and its Dis-*

The Weaning of Furniture-Nutrition, 1934

57

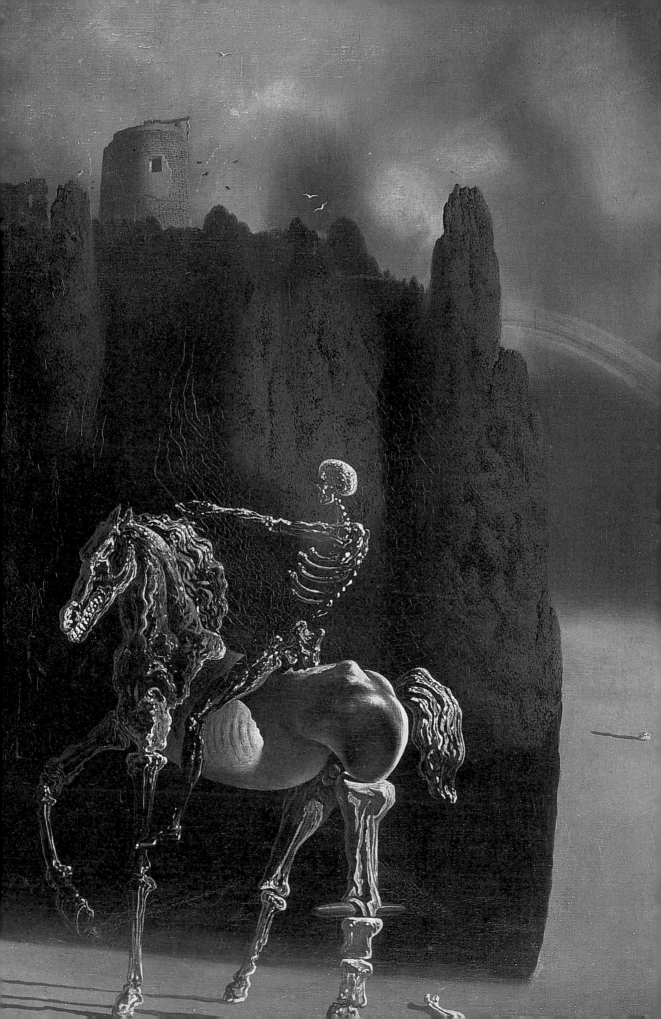

contents (1930) he comes back to the problem. Here the death wish is seen as a self-destructive, aggressive instinct, which shares mastery of the world with Eros. Freud suggests that the "phenomena of life could be explained from the concurrent or mutually opposing action of these two instincts." The concurrence is important because "the two kinds of instinct seldom – perhaps never – appear in isolation from each other, but are alloyed with each other in varying and very different proportions and so become unrecognisable to our judgement."[40]

In the same year (1930), in *La Carne, la Morte e il Diavolo*, the Italian writer Mario Praz examines the inseparability of love and death, beauty and sadness in Romantic thought. The idea was familiar to Dalí: when he and Gala first met, she did not use the expected language of erotic sexuality. On a walk along the cliffs of Cadaqués, a love–stricken Dalí asked, "What do you want me to do for you?" to which she replied, "I want you to kill me!" And in his childhood memories, there is a play on words making a connection between the devil ("diablo" in Spanish) and the children's game called "Diabolo." A murderous game with his little friend Dullita seems to be coming to a fatal climax only to end harmlessly when a diabolo is sacrificed, falling from the tower into empty space instead of Dullita.

In *Autumn Cannibalism* and *Soft Construction with Boiled Beans: Premonition of Civil War*, Dalí presents the fatal seriousness of the Spanish Civil War, trying to interpret the political situation in terms of psychoanalysis. Despite knowing how to use knives and forks, humanity has had a relapse into some earlier stage of civilization, there has been an outbreak of atavistic impulses and human beings are returning to their oral phase. Whereas the "flesh obsession" that Julien Green so aptly identified in Dalí (in a diary entry from October 16, 1933) once meant a particular feeling of attraction (Dalí once painted Gala balancing lamb-chops on her shoulders to show how much he loved both her and them), it now signifies the destruction of the object. These pictures are true allegories of the civil war in the sense that it involves the self-mutilation of one nation, that is to say of people who originally liked each other. According to Freud, even cannibals do not eat the enemies they could in some way like. But modern warfare has become so abstract and indirect that, in its level of cruelty, it surpasses the atrocity of cannibalism, which does at least respect the occasional taboo.

The Horseman of Death,
1935

59

One event which proved this was the bombing of the town of Guernica in April 1937. The masterpiece, the "obituary" which Picasso created in response, gave Dalí something to chew on. One result of his attempt to digest this was *The Debris of an Automobile Giving Birth to a Blind Horse Biting a Telephone*, a caricature of the horse in the centre of Guernica. By equipping his own horse with the rudiments of modern transportation and communications technology, Dalí is pointing to the way in which Picasso's visual world manages to get by with wholly timeless objects. The most up-

Autumn Cannibalism, 1936

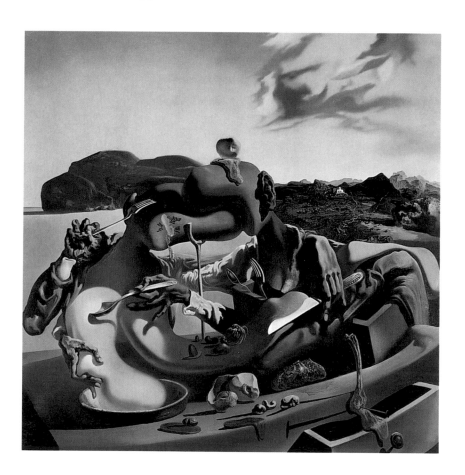

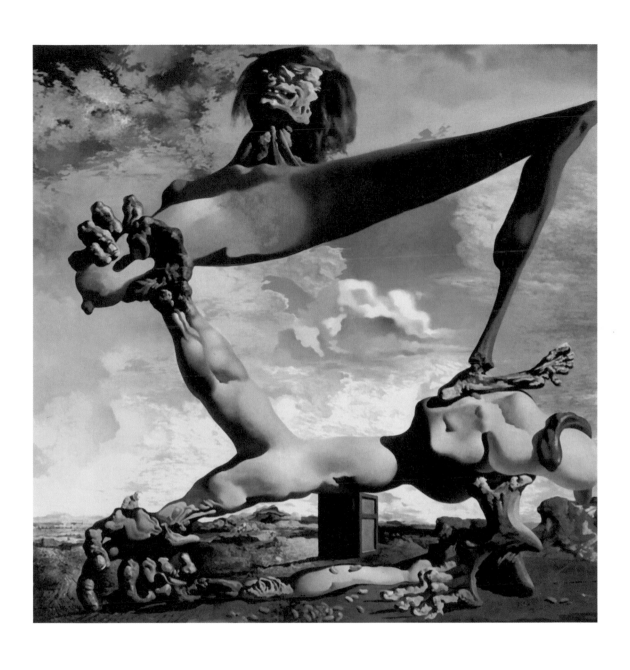

Soft Construction with Boiled Beans: Premonition of Civil War, 1936

to-date object in all of Picasso's work – besides one radiator (and not counting the works themselves) – is in fact the naked light bulb of *Guernica*. And even this was missing in the studies for the piece. (As such, Picasso was making a deliberate contrast to the theme of the world exhibition: "Technology in Modern Life"). He sent an automobile back down the paths of evolution for it to be transformed again into a baboon. Bicycle handlebars and saddle would regress into a steer's skull.

Dalí was less biased than Picasso – open to many things, assimilating many things – from the stone age to the holograms of the present. But he does not need all of this; often a minimum will suffice. *The Face of War* basically consists of only two elements, the head reduced to little more than a skull and the snakes twining around it as on a head of Medusa. The work's subtle composition creates a metaphor for unending terror. War is no longer the father of all things, but is only the father of all wars, which give birth to wars, which again conceive other wars, which bring forth yet more wars… The most terrible of all living beings is the human being. When humans have destroyed themselves, an imprint in stone will be all that is left of them. (Here the imprint is of the artist's own hand, the only incidence of that motif in all of Dalí's work.) Vereshchagin's

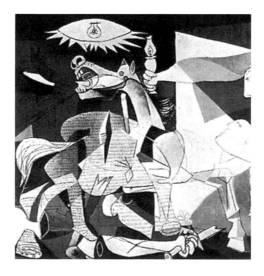

Pablo Picasso,
Guernica, 1937, detail

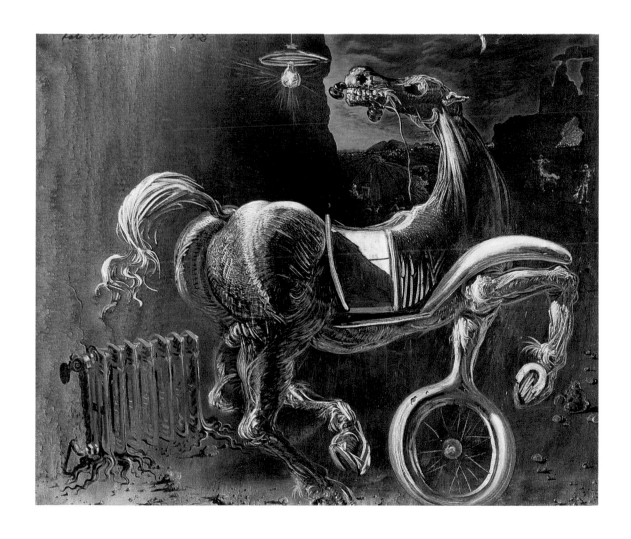

The Debris of an Automobile Giving Birth to a Blind Horse Biting a Telephone, 1938

pyramid of skulls has toppled over, its peak now lies in the viewer's head. The birds from *The Horseman of Death* are no longer to be found here.

But they do reappear on an untitled painting intended for a U.S. Army campaign against sexually transmitted diseases. Whereas *The Face of War* shows a consequence, reveals a cause. The front of death's skull dissolves into a pale area of light while the teeth are turning to flesh. The fact that our understanding of either is not impaired, and the ease with which the parts of the prostitutes not concealed by skirt, stockings, or suspenders can also function as teeth is a testament to Dalí's imagination and skill. There is also a degree of ambiguity in the look on the female officer's face – equal

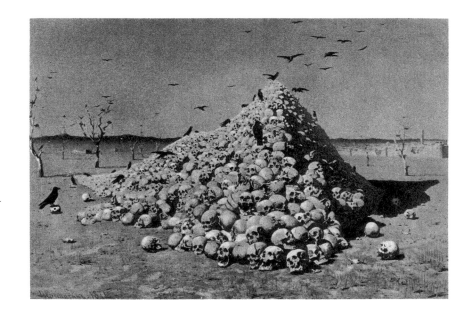

Untitled (For a
U. S. Army Campaign
Against Sexually Trans-
mitted Diseases), 1942

Vasily Vasilyevich
Vereshchagin,
Apotheosis of War,
1871

64

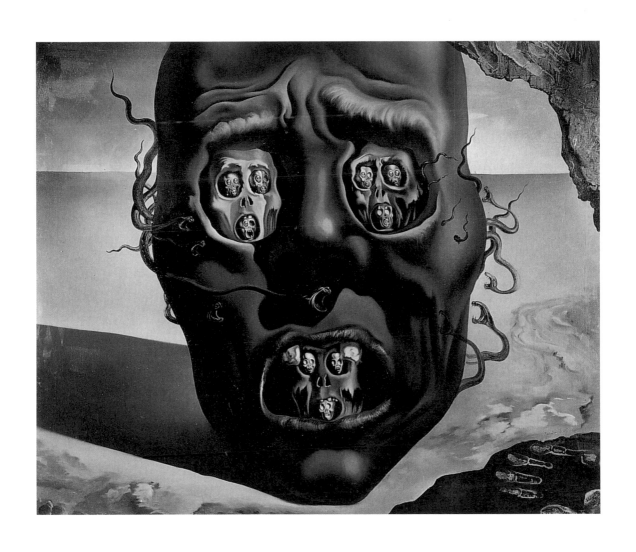

The Face of War, 1940

measures of outrage, reflection, and guilt. Whether, and if so, how, this picture was in fact used in any such campaign is not known. The theme suits Dalí's paranoid method well, which he himself had already described as resembling military camouflage. On the other hand, a poster of this sort would probably have been too Surrealist, too ambiguous – for soldiers could have interpreted it quite differently: our business is death but afterwards we will be rewarded with love…

Dalí also arranged a living picture of the brotherhood of Eros and Thanatos – yet another facet of the *uomo universale*. In his work with live models, which is more about preparation than imitation, he prefigures Yves Klein's "living paintbrush." He called on the help of the Hungarian photographer Philippe Halsman, whom he had got to know in 1941. Their collaboration led to a series of highly original works, starting ab ovo with an image of the intra-uterine artist.

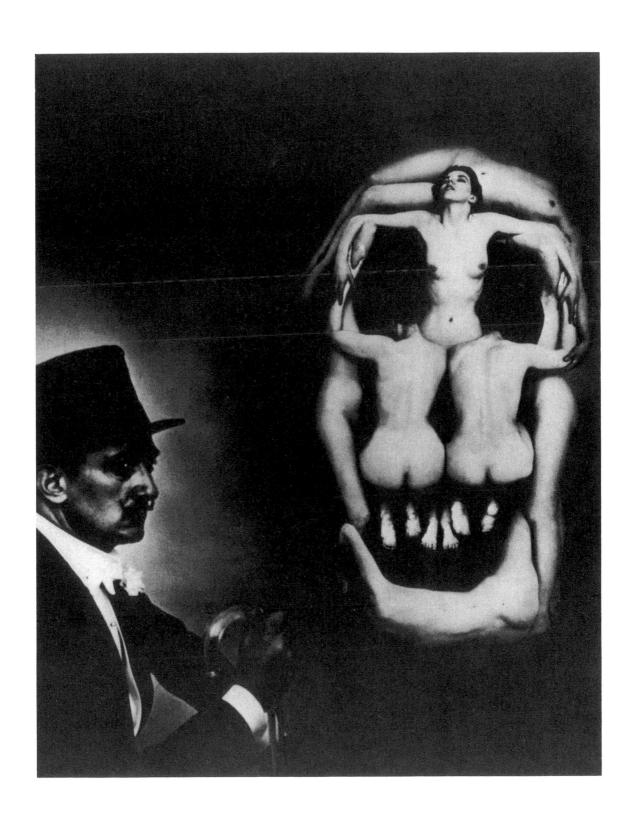

Dalí with models for *The Face of War*, photograph by Philippe Halsman

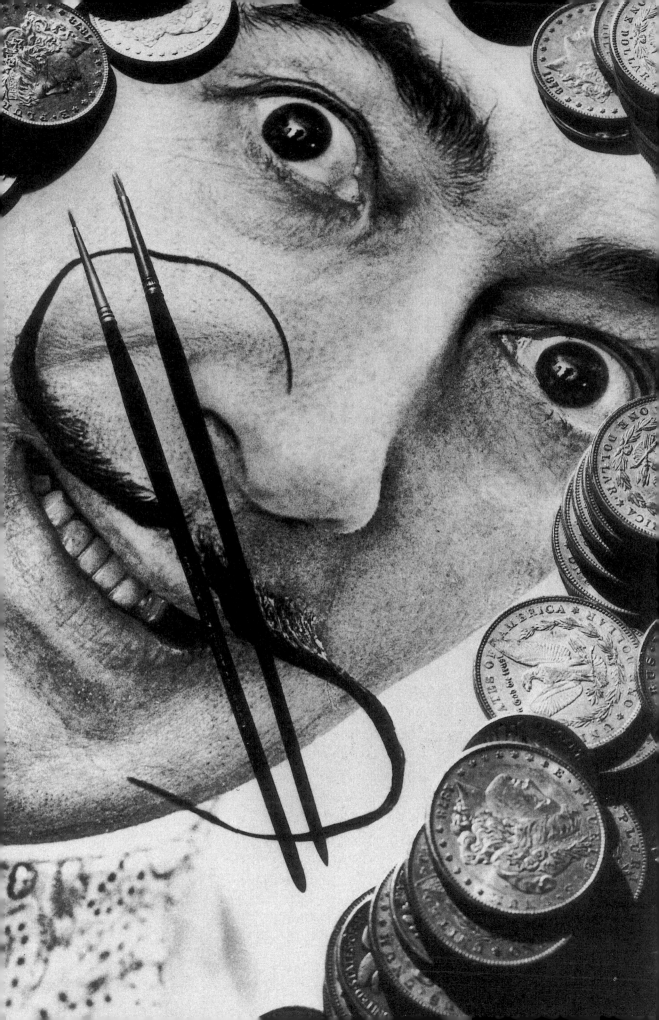

Auri sacra fames

Since Mandeville, economists have known the maxim that private vice can produce public good. Older than this is the notion that the holy and the damned can look confusingly similar. Virgil was certainly not thinking about the beneficial effects of the thirst for true freedom – rather of the destructive effects – when he wrote, "Whither do you not drive the mortal heart, unholy thirst for gold?"

We have already seen that fame meant more to Dalí than riches (p. 7). But even the prospect of fame was not the real driving force behind his work, for the work was much more an end in itself. Like all "workaholics," he simply worked for the love of it. But, in order to be able to do so at all, he needed money. At first, acquiring money was purely a matter of luck.[42] That is not to say that Dalí did not want to take on any commissions; it was simply that, for him, the connection between work and money was no more than accidental. "I worked a hundred times harder than any mediocre painter, preparing new exhibits. For the smallest order I put all my blood into my work. Gala would often reproach me for putting such great effort into the execution of insignificant and miserably remunerated orders. I would answer that inasmuch as I was a genius it was a veritable miracle that I got any orders at all."[43]

And yet there is a widespread belief that Dalí was a particularly commercial-minded, money-oriented artist corrupted by wealth, and thus the very embodiment of capitalism in all its greed. This belief goes back to a simple anagram of the name SALVADOR DALI which occurred to André Breton (ten years after the invention of the forerunner of Scrabble), and which appeared in a magazine that Breton had founded in New York: it was AVIDA DOLLARS (1942). The anagram is supposed to mean "hungry for dollars" but, from a grammatical point of view, is rather clumsy. The object of the hunger should be in the genitive case and the adjective is feminine – although this in itself would not entirely be without justification, because it is fair to say that the couple's business concerns were

Photograph by Philippe Halsman from "Dalí-Moustache", 1954

energetically handled by Gala. And why not? Otherwise the two would surely have gone under.

When Ana María reports that, as a child, her brother had effortlessly identified the one fake banknote in a bundle of 25-peseta notes,[44] this speaks for his powers of sight and not necessarily for a particular aptitude for finances. In fact he clearly had problems with the abstract nature of money, being more interested in its appearance and feel. Even at the age of 25, he allegedly believed that 500 francs in small denominations were worth more than one single 1000 franc note.[45] And his sensational money-changing exploit was not merely a thing of his schooldays. In the early '30s it returned as a counter-cyclical investment strategy: "As soon as the money began to diminish the first precautionary measure we took was to give bigger tips wherever we went."[46] Such behaviour would soon have spelt ruin if Gala had not responded in a way that gave her the reputation of simply being out for money: when she was discussing prices for Dalí's works over the phone she "would agree verbally to a price in pesetas and then pretend that she had made the deal in dollars."[47] She was an unusual mixture of stingy and extravagant. Losses in casinos led her in later years to put the selling of Dalí's works into not always entirely reliable hands. In her case, there must have been an urge stronger than the straightforward desire to be as comfortably off as possible. Had that been the case, she would not have saved up countless checks in her wallet that were never paid in to a bank, or have kept in a safe banknotes that were no longer valid currency. She was a "compulsive hoarder"[48] who liked nothing better than to hold on to any cash that had come in for picture sales. But one should tread warily when it comes to characterising an individual on the basis of individual observation and general gossip. And all the more in Dalí's case, for he put the whole question on a different, perhaps facetious, level when he examined himself for the connections established by Freud "between the complexes of interest in money and of defaecation."[49]

More artful than the anagram on his name is the way that Dalí, with Philippe Halsman's assistance, gleefully took up the challenge of Breton's libel in a photograph where paintbrushes and Dalí's moustache form a dollar sign while coins fall from his head like curls.

There can be no doubt that Dalí points the way to the works of such figures as Warhol and Beuys, with their response to consum-

The Poetry of America: The Cosmic Athletes, 1943

70

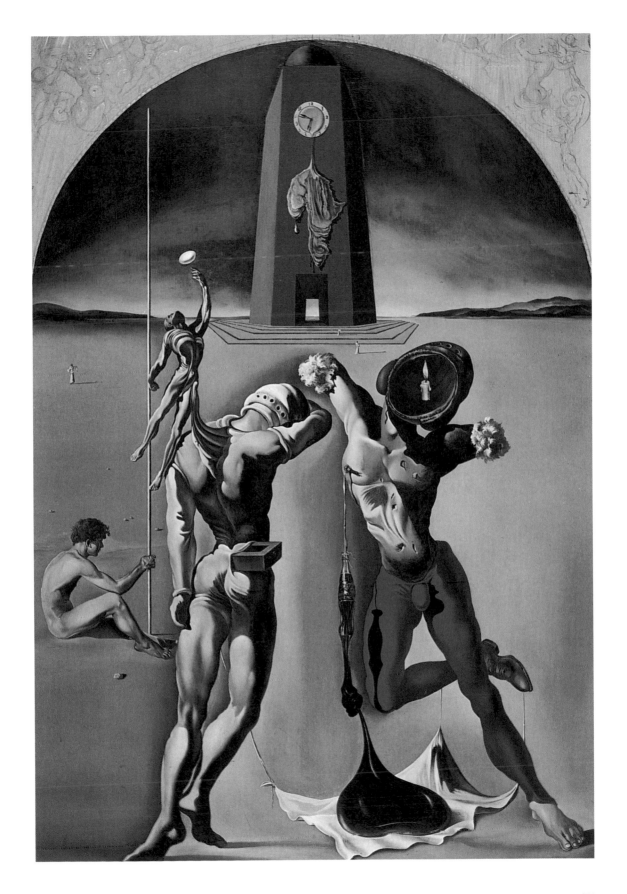

erism and capitalism. As early as 1943, Dalí painted *The Poetry of America* – a Coca-Cola bottle in the centre of a ballet with football players, all beneath a depiction of the tortured continent of Africa.

The Enigmatic Path (1981) is lined with sacks of flour and gold. The picture's composition in the form of a large X recalls Dalí's *Surrealist Composition* from over a half-century earlier. What, in the later painting, is seen to contain flour and gold – with grain being a symbol for profits and possessions – has, in *Surrealist Composition*, a physiological aspect, like goose-pimples at the prospect of the path leading into the future.

Dalí's ways with money were certainly chaotic and unfortunate. But the claims that he lusted after money are not convincing, particularly those made by people faring less well themselves and whose socialist options hold little hope for the future either. And in view of the current value of his works – estimated with increasing objectivity thanks to the number and expertise of those who judge these matters – one would have to rate as modest the prices that Dalí charged when he created those works. All his clowning was no more than a cry for help from one who was both underchallenged and undervalued.

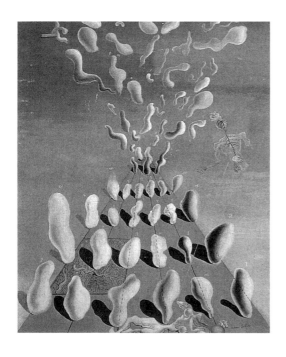

Surrealist Composition, 1928

Facing Page:
The Enigmatic Path,
1981

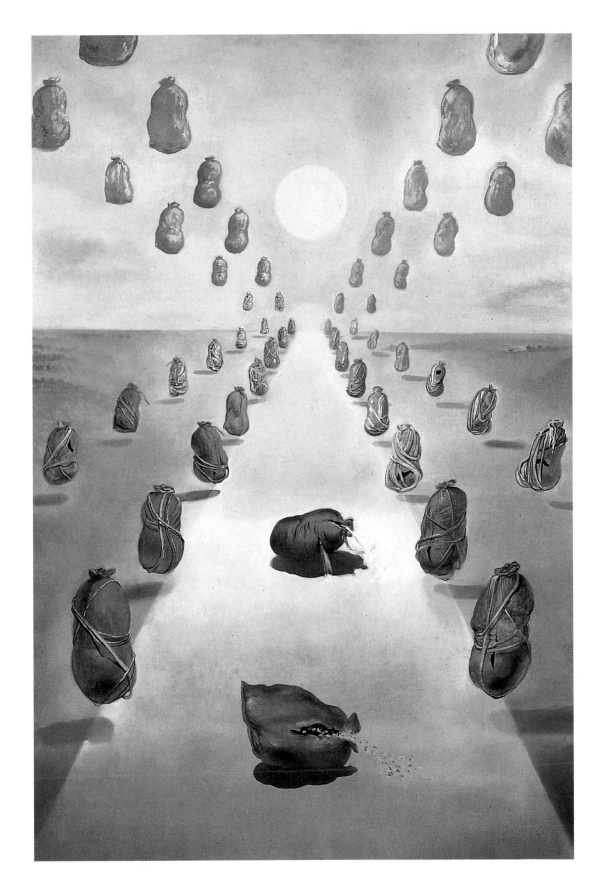

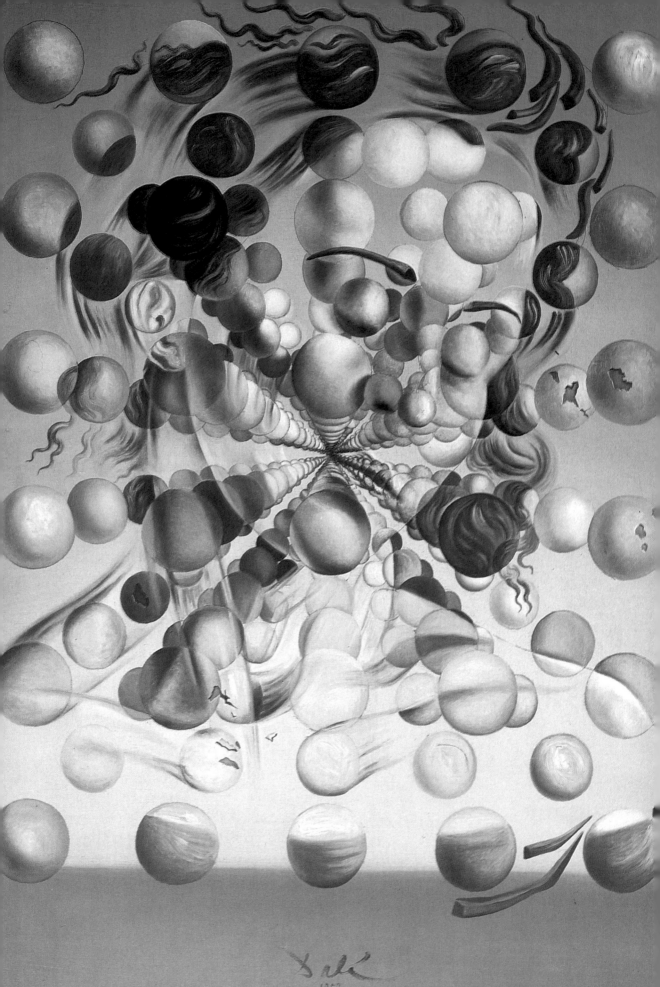

Curiosity

Natural curiosity which, according to Giambattista Vico, is the daughter of ignorance and the mother of knowledge, engendering wonder and opening the mind, was also the mother of Dalí's art. His hunger for knowledge was satisfied first and foremost by readings on psychoanalysis, physics, biology, and mathematics. Psychoanalysis dominated until the second world war, after which the natural sciences took over. Once he was able to read English, Dalí subscribed to the *Scientific American.* In a certain sense the shift of interest corresponds to a natural development, in that sexuality has a greater role to play in one's youth than in later years. As he told one of his biographers, the personalities Dalí admired above all and who had influenced him most were Freud and Einstein.[50]

One might surmise that Dalí was primarily attracted by the fame of the scientists in question, in the way that he became interested in DNA (deoxyribonucleic acid: the major constituent of chromosomes) when Watson and Crick received the Nobel Prize in 1962, but had not been interested when they made their discovery in 1953 – or that he turned to holography when Dennis Gabor received his Nobel Prize in 1971. Now it would be utopian to suppose that a visual artist could reach the same heights in the natural sciences as a specialist would. An artist can nonetheless create works – without being fully aware of it – which happen to bear a structural resemblance to the findings of the natural scientist.

Thus *Galatea of the Spheres* (1952) shows a molecular structure that demonstrates Dalí's susceptibility to structures such as that of DNA. In the matter of holography, his work with stereoscopy and multiple images goes back considerably earlier than Gabor's discovery in 1948. But when Dalí claims to have drawn a double helix intuitively, even before Watson and Crick, this can be dismissed as exaggeration, particularly since no such drawing is known.

But then again, there are instances which serve to allay the suspicion that he would opportunistically try to share the limelight

Galatea of the Spheres,
1952

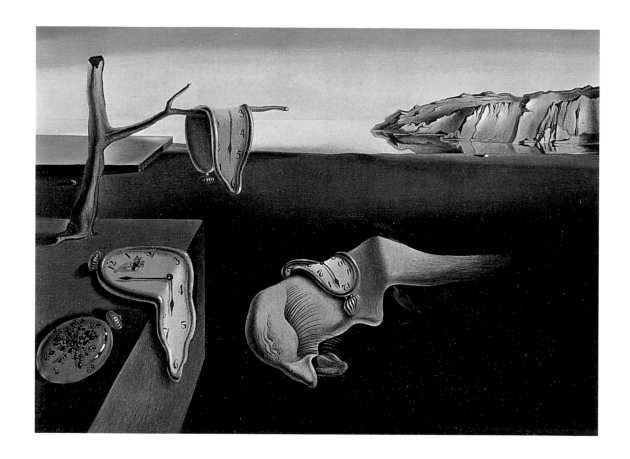

with others simply because of their success. He praised Lacan's dissertation on paranoia, for example, before the latter was at all well known, and he knew about virtual reality, catastrophe and chaos theories long before everyone was talking about them. (The fact that René Thom was awarded the Fields Medal did little to attract the public's attention to his works.)

The Persistence of Memory is a visualization of the theory of relativity, insofar as the theory makes time and space "soft," ridding them of their absolute rigidity, stretching and compressing them, moulding and bending them, according to the whim of the individual viewer. But this is not the first appearance of watches in Dalí's work. Already in the *Premature Ossification of a Station* (1930) there is a somewhat deformed station clock which seems to be continuing

The Persistence of Memory, 1931

76

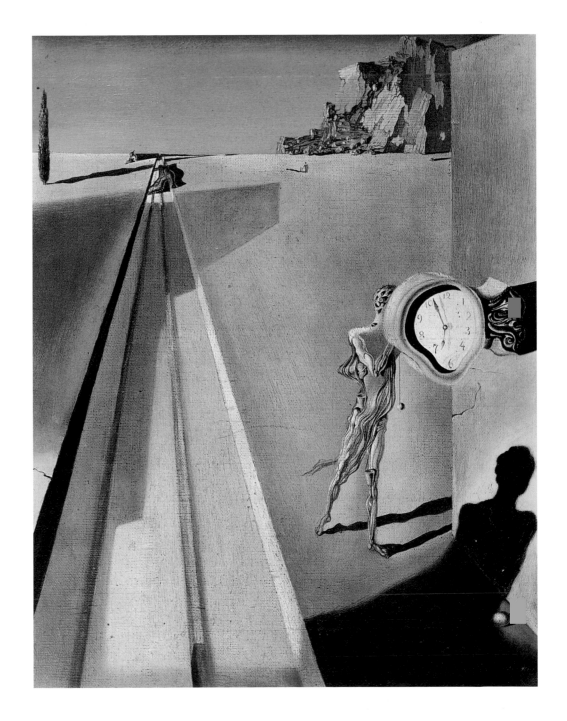

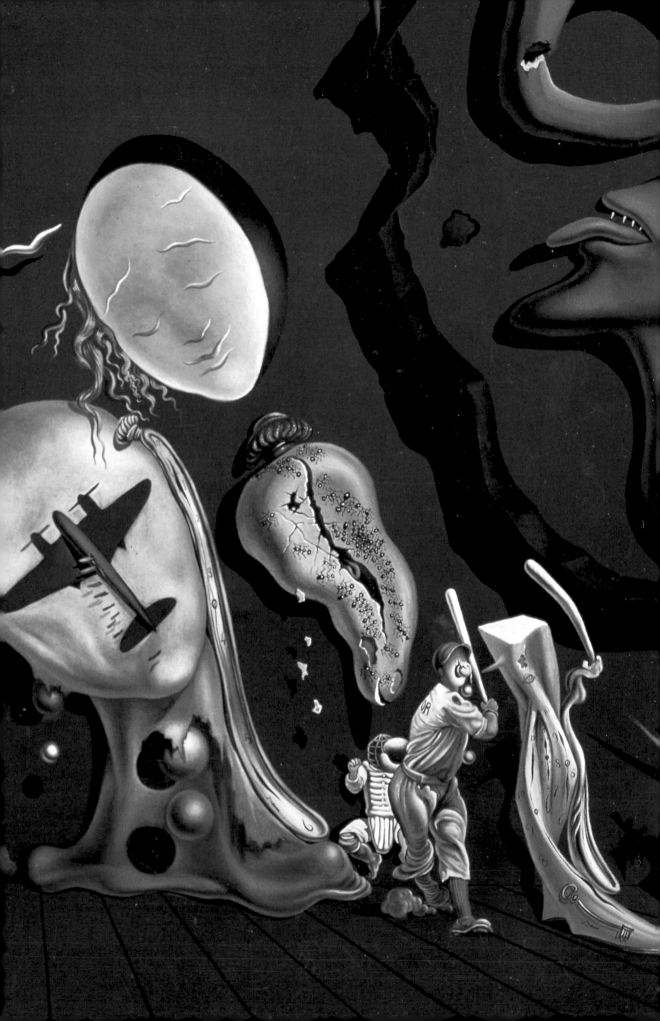

the Art Nouveau curves of the bracket which attaches it to the wall. The track disappearing into the distance reveals the origins of the clock motif in the work of de Chirico. Thus, whereas Dalí depicted an aspect of the theory of relativity at a time when it was already well known, de Chirico had – unknowingly – painted some of its basic elements while the theory was still being developed.[51] By the time Dalí entered his first major period of creativity, leading physicists had long turned to other questions – wave particle dualism, complementarity, and the theory of "holes." And Dalí had unconsciously found images to illustrate these (in his *Large Harlequin and Small Bottle of Rum*, 1925, p. 21), even slightly before Niels Bohr and Paul Dirac.

One of the ironies of world history is that one of the most brilliant discoveries of the twentieth century led to the unleashing of the most powerful of destructive forces. It was fitting and prophetic that Schumpeter formulated the notion of creative destruction – also applicable in art – in the year 1942.

The atom bomb was indeed the visual "realization" of abstract theories. If it is said that artists were struck dumb in the face of this event,[52] then Dalí is one of the few exceptions. He painted his *Melancholic Atom and Uranium Idyll* immediately after the bombs in New Mexico, Hiroshima, and Nagasaki (the second using uranium as opposed to the plutonium of the other two). The sarcastic word "idyll" may refer to the seemingly harmless little plane which droned by in the sky above Hiroshima on the morning of August 6. In Dalí's painting it forms the eyes, nose, and mouth of a melancholically bowed head. A soft watch leans up against it. Melted clocks and watches that had stopped at 8.15 a.m. were subsequently found amongst the debris of the annihilated town... On the right, the atomic fire burns. Its energy comes from the neutrons released during the nuclear chain reaction, which are seen here bursting out of every possible container, even out of a larynx. Dalí adds his own suggestion to the liquid–drop model: a nuclear baseball.

The Three Sphinxes of Bikini was painted in 1947 after the United States had begun to test atomic bombs in the Pacific around Bikini, one of the atolls among the Marshall Islands. Dalí transformed the familiar metaphor of an atomic "mushroom cloud" – also used in French, Spanish, and Catalan – into heads with white curls above smooth necks which, in turn, seem to resemble mighty trees. Earlier,

Melancholic Atom and Uranium Idyll, 1945, detail

79

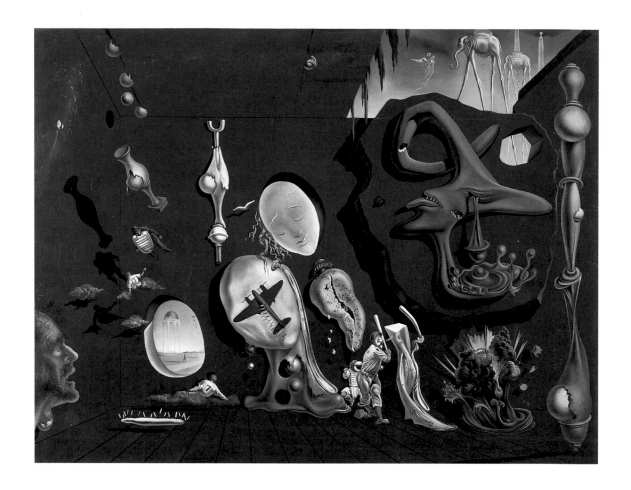

Dalí had already interpreted a mass of cloud as a skull which, when split by lightning, revealed "the quicksilver brain of the sky itself."[53] On another occasion he used mushroom-shaped clouds for a cover design for *Minotaure* (1936) – a strange premonition. While its visual aspect lends itself to many imaginative reinterpretations, the bomb is politically and philosophically as ambivalent as any sphinx: the question is whether the tests are necessary or "malevolent madness," to quote Thomas Mann. The unique beauty of the New Mexico desert – torn out of the night by a bomb explosion brighter than a thousand suns – was a landscape created just for Dalí in its hyper-sharpness and plasticity – and a stark contrast to the disgusting tox-

Melancholic Atom and Uranium Idyll, 1945

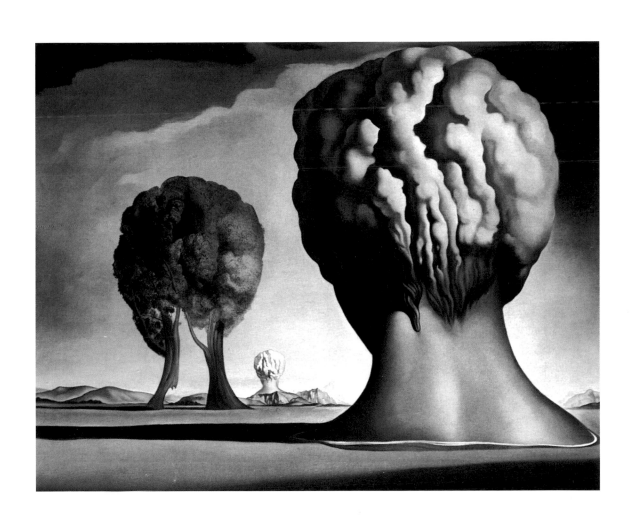

The Three Sphinxes of Bikini, 1947

icity of the whirlwind of dirt that ensued. *The Three Sphinxes* shows the brief silence immediately following an atomic detonation – the majestic, absolute quiet before the storm and its fallout.

There can be no more affecting image of the terrible unity of creation and destruction than the moment when the first atomic bomb was dropped and its maker, J. Robert Oppenheimer, quoted Krishna in the Bhagavadgita: "I am death, who taketh away all, the destroyer of the worlds."

The impending advent of a new era is heralded in Dalí's *Geopolitical Child Watching the Birth of the New Man*. The ghost of Lebensraum-fantasies and the theory of the dualism of oceanic and continental powers will soon disappear. From out of the ovum mundi, which is also the atomic egg, a new order will emerge, characterized by the East-West conflict under the fragile roof of the United Nations.

There is an indirect link between Dalí and Oppenheimer in the person of Haakon M. Chevalier. He was a professor of French literature and Romance languages at the University of Berkeley and had been a friend of Oppenheimer's since 1937. In 1941 – 42 he translated

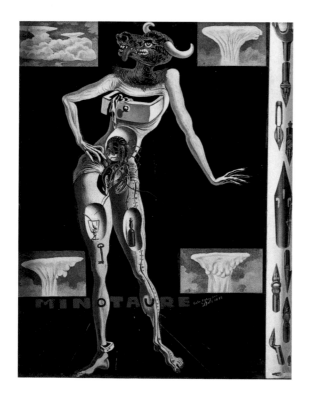

Cover for *Minotaure*, No. 8, 1936

Facing Page:
Geopolitical Child Watching the Birth of the New Man, 1943, detail

82

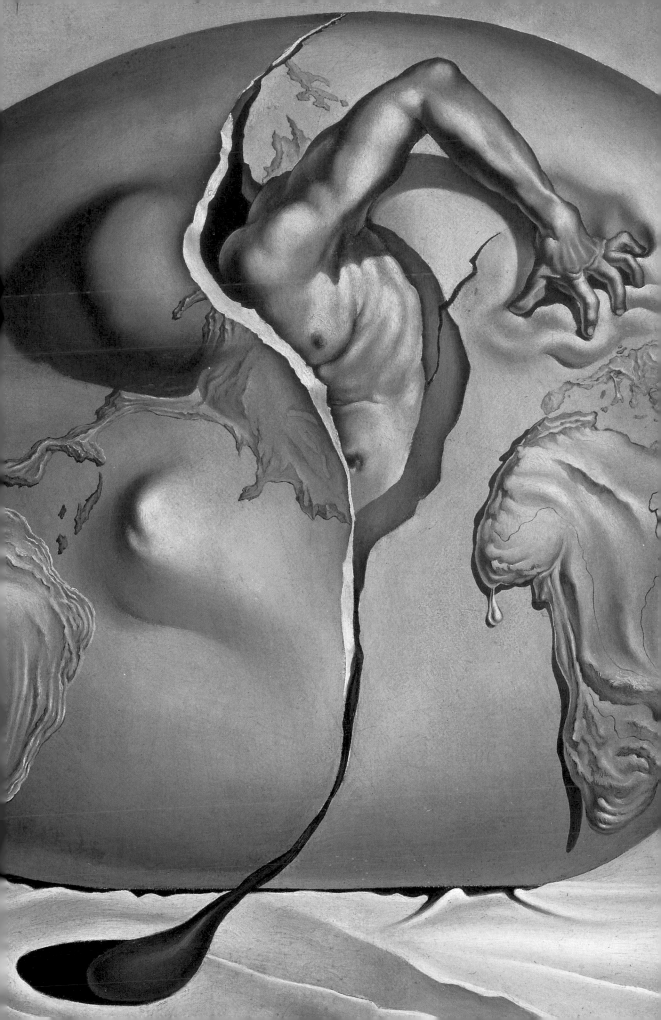

Dalí's autobiography. A few years later he was to lose his professorship; because of his sympathy with Marxism and Communism, he was accused of espionage on behalf of the Soviet Union. In 1954 Oppenheimer was similarly classed as a security risk by the Atomic Energy Commission and not rehabilitated until 1963. Oppenheimer and Dalí shared the experience that art and science need expect little to the good from – all too mediocre – politics, whereas their two disciplines could work all the more productively together. Dalí's declaration of the rights of man to his own madness complemented Oppenheimer's declaration of "man's right to knowledge and the free use thereof": "Both the man of science and the man of art live always at the edge of mystery, surrounded by it; both always, as the measure of their creation, have had to do with the harmonization of what is new and what is familiar, with the balance between novelty and synthesis, with the struggle to make partial order in total chaos. They can, in their work and in their lives, help themselves, help one another and help all men. They can make the paths that connect the villages of arts and sciences with each other, and with the world at large, the multiple, varied, precious bonds of a true and world-wide community."[54]

Dalí soon crosses between the "two cultures" in *The Splitting of the Atom*. He may be limping along nine years after Hahn and Straßmann's discovery of nuclear fission in 1938, but he is twelve years ahead of C.P. Snow. Classic and ultra-modern, culture and nature, macrophysics and microphysics, words and images are all brought together as one floating whole. The "dematerialized" nose of Nero (here turned, as though accidentally, into "Nemo," i.e. "nobody") is a play on the transformation of mass into energy, while the free space between the various objects emphasizes that our apparently so solid world consists largely of space and that gravity is perhaps no more than the illusion of a body hurtling through the cosmos.

This floating state would dominate many of Dalí's works for years after this, thus anticipating not only C.P. Snow, but also Sputnik. In a series of photographs made with Philippe Halsman for *Life*, Dalí himself floats through the air along with loaves of bread, chairs, water, and several cats who seem to prefigure the husky dog Laika, the first living creature in outer space. These shots were made by endlessly throwing the cats into the air and catching them again, soaked to the skin – somewhat similar to the way, from 1951 on-

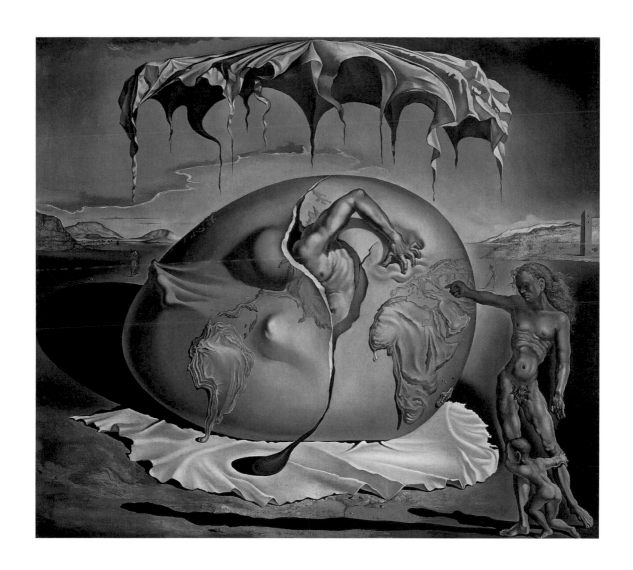

wards, Soviet scientists launched several rockets transporting dogs wearing pressure suits which safeguarded their return to Earth by parachute. In this light, Dalí's experiments were perhaps rather more reasonable and less harmful ...

While *Leda Atomica* still employs the visual language of classical mythology, *The Madonna of Port Lligat*, in its equally complex geometric construction, draws on Christian iconography. This shift was already evident in *The Resurrection of the Flesh*, with *The Temptation of Saint Anthony* signalling an intermediate stage in the movement of figures and objects upwards and away from the ground. The weight

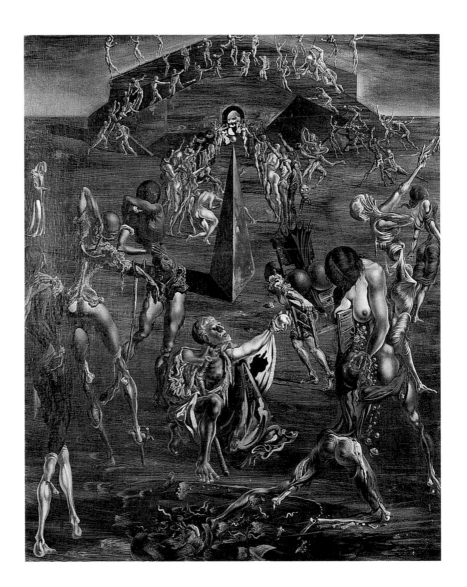

*The Resurrection
of the Flesh,* 1940 – 45

Facing Page:
*The Splitting
of the Atom:
Dematerialization near
the Nose of Nero,* 1947

of the elephants has been much reduced, they still cling to the earth
with their insect-like legs. In fact, the phenomenon of levitation is in
its nature the province of the Catholic Church. The saint for whom
the most levitations are recorded was the Conventual Franciscan
Joseph of Copertino who lived in the seventeenth century. Liturgical
music and masses transported him into ecstasies which made his
features glow and caused him to rise up from the ground. In 1963 he
was named as the patron saint of space travel. Now in Dalí's work,
the connections between art and science are reinforced by the link
between physics and religion.

The Madonna of Port Lligat (first), 1949

Leda Atomica, 1949

But the first, most important question is, who is being borne aloft here? It is Gala. It may well be that no other artist has idealised his wife as did Dalí. And it may equally well be that no other wife has been so harshly criticized by others as was Gala. One need only take *Galarina* (p. 120), Dalí's perfect, classically beautiful portrait, speaking of his devotion and reverence, and compare it with the opinion of one of Dalí's biographers who describes the same woman as "a personality of such relentless self-will, such monumental self-regard, such icy disregard for the feelings of anyone except herself, that she sent shivers down the spine of almost everyone she met."[55]

It is hard to decide which is true, but where there is doubt, the artist's portrayal is the more convincing one. In any case, it would be fair to say that, as much as Dalí placed his wife on a pedestal of untouchability and perfection, so too the shocking reports about her were not merely malicious gossip. Compensation and sublimation are all too palpable in *Leda Atomica* where not even the water is touching the ground. The scrolls on the pedestal retain their position despite not being attached in any way, and it seems unthinkable that Zeus as the swan will be able to approach this woman any closer. Since the concept of chastity had no place in antiquity, there is logic in Dalí's shift to Christian iconography – and to the synthesis of the two in the Renaissance. The hole in the chest of the Christchild – himself floating in a hole in the chest of the *Madonna of Port Lligat* – is reminiscent of the view through a building in Raphael's *Sposalizio* and the egg could make us think of the egg of Piero della Francesca's *Pala di Montefeltro* (both paintings hang in the Pinacoteca di Brera). The beauty and mystery of nature are to be seen in the sea-urchin shell – whose structure had already fascinated scientists such as Fibonacci.

In November 1949, Dalí carried off a true *coup d'éclat*: he had the opportunity to show this painting to Pope Pius XII in a private audience. The meeting had been arranged for him by a certain Captain Moore, an Irishman, a former expert in psychological warfare who was responsible for public relations in the Vatican. Thus Dalí confronted Breton, the Pope of the Surrealists, with the failure of that movement which had once been so intoxicated with revolution and had been founded, not least, on its hatred of religion; at the same time he confronted God's representative on earth with the three things notoriously guaranteed to cause embarrassment to the Cath-

olic Church: modern art, sexuality, and physics. (Copernicus and Galileo, for example, were ironically rehabilitated only after the theory of relativity had established that there could be no final answer as to whether it is the earth or the heavens that rotate – which was, of course, also not a reason not to rehabilitate them.) Whether the Pope understood Dalí's diplomatic artistry is open to debate. Whatever the case, he did give Dalí permission to marry Gala in church despite her having been divorced from Paul Eluard.

The Christian challenge posed by sexual lust is illustrated in *The Temptation of Saint Anthony*. After numerous frustrated attempts to deflect the desert hermit from his ascetic way of life – trying to wear him down with talk of relatives, friends and possessions – the devil has brought out his most powerful weapon and has sent a cavalcade of beautiful naked women to ride by. Steadfastly, Saint Anthony holds his meagre cross towards them, but now there is a moment of

The Temptation of Saint Anthony, 1946

91

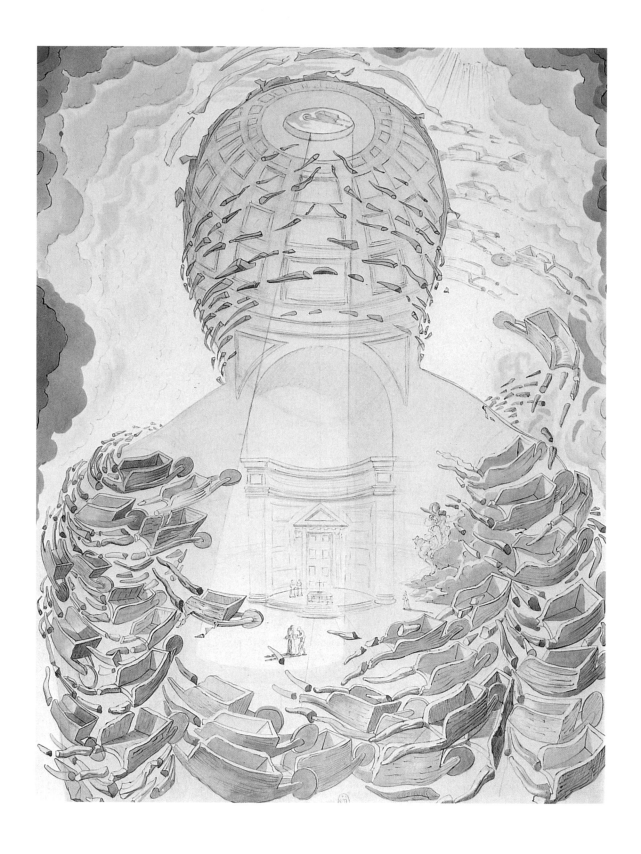

Les Brouettes (The Wheelbarrows), 1951

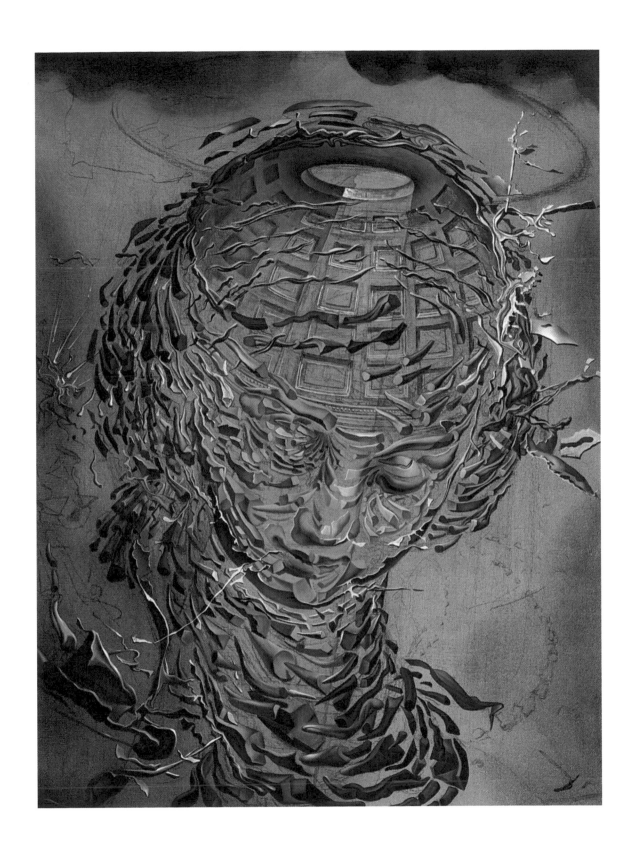

Raphaelesque Head Exploded, 1951

uncertainty, for it is not clear whether the horse is shying away or whether its hoof is about to crash down on him. This is the precise instant shown in Dalí's picture. The saint's halo threatens to become a vicious circle: the longer the hermit fights the lust he feels, the stronger the temptation becomes and the stronger the temptation, the harder he has to fight. The tension mounts – as the French and the Spanish say: every fly and each flea becomes an elephant. The figure forced into the defensive against the pleasure massing before him is the naked antithesis of the ideal that Saint Anthony would have had for himself: "Since every human being is spirit, then they must relinquish the things of this earth. All activity is degrading. I do not want to be stuck to the earth – not even with the soles of my feet!" (Gustave Flaubert, *The Temptation of Saint Anthony*). But instead of this the unfulfilled desires are taking off, bearing symbols of sublimations. The torso in the Renaissance building echoes that of *The Enigma of Desire*, the obelisk goes back to Bernini's idea of loading all the wisdom of the ancients onto the strongest possible

Dalí and Robert Kennedy in front of the painting *Christ of Saint John of the Cross,* New York, 1952

Facing Page: *Christ of Saint John of the Cross,* 1951

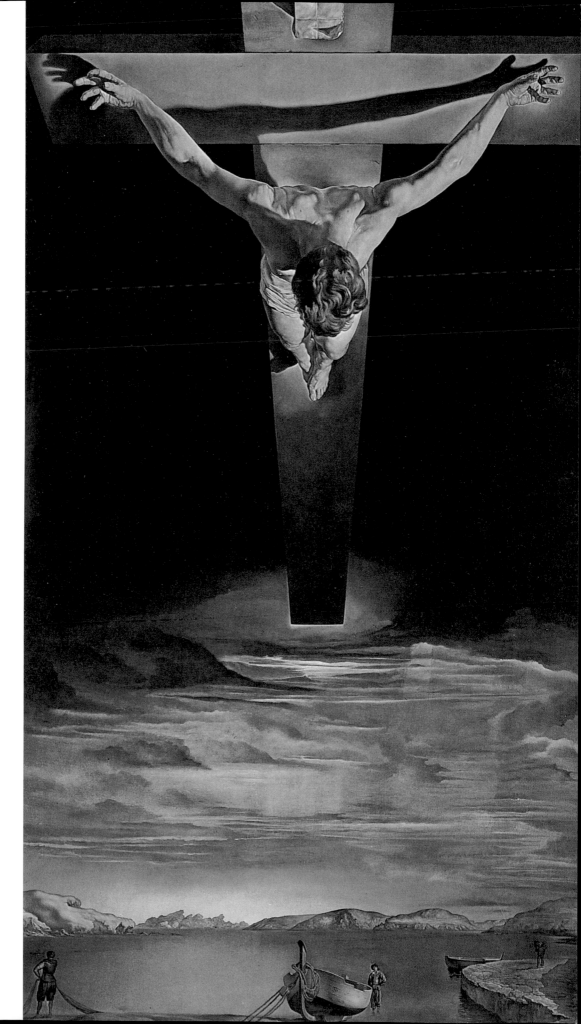

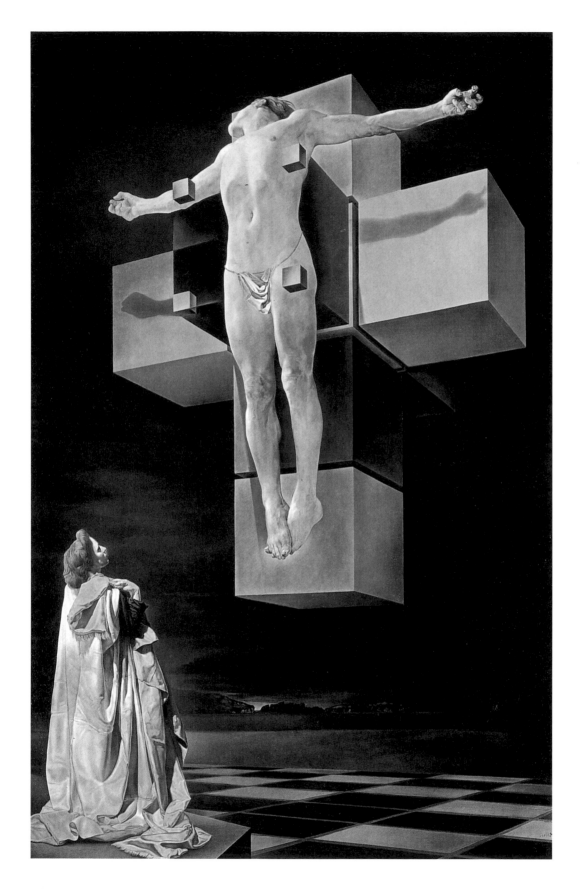

beast of burden, and the portrayal of Cloud-Cuckoo-Land has clear links with the Escorial. Saint Anthony is learning at his own expense the truth in the words of Horace, also quoted by Freud: "You may cast out Nature with a pitch-fork, but she will always return." The more he represses his sexuality, the higher his hallucinations ascend into the sky. Since he is not taking advantage of life, life is taking advantage of him. Dalí had an interesting "angelological" theory about this: "Sperm possesses angelic qualities because it is the holder of unconceived beings."[56]

There are two variations of the *Exploded Raphaelesque Head*, the double image of an Raphaelesque angel superimposed upon a view of the coffered dome of the Pantheon in Rome (where Raphael is buried). In one variation, the whirling fragments are in the form of wheelbarrows (an allusion to Millet's *Angélus*); in the other, the head is being bombarded with spermatozoa. While this may be an innovative depiction of the immaculate conception, Dalí's *Christ of Saint John of the Cross* is no less revolutionary (and shows how much less

Facing Page:
Corpus Hypercubus,
1954

Dalí emerging from a metaphysical cube at a press conference in the Palatto Pallavicini in Rome, 1954

97

originality is to be found in a crucifixion by Baselitz for example). Dalí's choice of an unusual triangular composition, which, along with the extreme perspective and dramatic, Caravaggio-like light and shadow on the figure creates a sense of cosmic breadth, was inspired by a drawing which Saint John apparently made after an ecstatic vision. Juan de la Cruz was the first member of the monastery founded in Duruelo by Saint Teresa of Avila in 1568. Both came from the Carmelites' stricter order, the "Discalced Carmelites." Going barefoot was part of the particular asceticism of their lives and was intended to heighten their mystical awareness of God. Dalí could respond to naked feet. He imagined that Christ's feet must have had the scent of fresh roses. The small size of the feet in the Glasgow crucifixion is dictated by perspective and made up for by their central position. The link between mysticism and atomic physics lies in the notion of concentration. Before the chain reaction culminates in ecstasy, dark night must first be traversed. In 1952 Juan de la Cruz was named the patron saint of Spanish poets. Dalí had long been familiar with his poetry from García Lorca's frequent recitations of his verses.

For *Corpus Hypercubus*, Dalí chose to portray Christ from the opposite point of view. Gala, swathed in heavy, precious fabrics, looks up to the floating, crucified figure. Gold, yellow, and brown dominate the picture with only the contrast of one dark blue sleeve. "Corpus" refers not only to the body of Christ, but also to any geometric figure. This opens the way to an intellectual experiment. The transcendental, metaphysical space which God inhabits is as inaccessible to the human imagination as is the fourth dimension in geometry. But it is possible at least to approach them by means of analogy. We know how the third dimension derives from the second. At the edges of a square, four more squares are drawn, each taking up one side of the original square. These are then folded upwards into the next dimension and, with the addition of a further square set parallel to the original square, a cube is formed. Here Dalí attempts to do the same thing with a cube. He places cubes of the same size on its surfaces, with an extra cube on one surface to elongate the cross. Only, what space do we now fold these up into in order to create the hypercube, the cube in the fourth dimension?

In the year when he completed this painting, as part of his "action teaching" at the Pallavicini Palace in Rome, Dalí climbed out

Still Life Fast Moving, 1956

of a "metaphysical cube." What matters here is the spirit of the action, and not taking Dalí to the letter. And yet letters are a wonderful medium. The permutations of letters on the cube recall the logical art of combinations created by the medieval theologian and philosopher Ramón Llull, whom Dalí respected so highly. Another admirer of the Catalan philosopher was Juan de Herrera (1530–97), the architect of the Escorial. Cool design and considered proportionality are the hallmarks of his buildings. What he valued in Llull was his belief that science and logic should go hand in hand with religious belief; like him he believed that, at its core, Creation was structured according to reason and harmony. Herrera wrote a summary of Llull's system, the *Discurso de la Figura Cubica* (*A Treatise on the Cube*) which gave Dalí some concepts for images, such as the cube grid.

The Railway Station at Perpignan, 1965

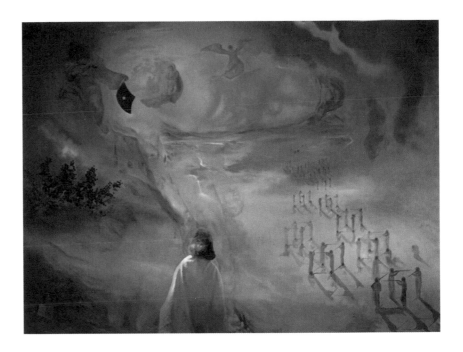

One possible way of imagining the fourth dimension is to think of it as time. *Still Life Fast Moving* hints at it in the traces of movement left by the apple, the cherries, the knife, and the bottle of water, while there is no sign of movement from the swallow, which would never hold so still in real life. A dramatic attempt to escape the dimension of space is made by the fruit bowl although, unlike the balcony rail, it breaks as it twists.

In *The Railway Station at Perpignan* (1965) the theme of still motion is taken up again. Dalí is falling but there is someone who catches him with infinite tenderness.

From physics to molecular biology: *Galacidaladeoxyribonucleicacid* mingles the artist's genetic make-up with that of his wife, Allah and El Cid, the Spanish military commander. As Gala watches, God raises his dead Son, whose side is still bleeding, up into heaven. Dalí links the circling upward movement to the spirals of DNA. The spiralling double helix of Watson and Crick storms full force into the picture as a group of riders. It is contrasted on the right by an inorganic structure, with formalised Arabian figures in cubic crystals holding each other in check.

Still called a "child" at the age of thirty by his relatives, when he was over sixty, Dalí was well attuned to the times – and even ahead of them. When Roger frees Angelica, he kills the dragon with a laser gun. Dalí understood the "digital" challenge to painting even before it quite existed. He used the word "virtual" (which had been familiar, of course, to Leibniz, Wölfflin, and physicists) in an informed way long before it had made its revolutionary, triumphal entry into post-modern life (and falling prey to the terrible banality that eventually characterizes every mass phenomenon). It goes without saying that the cyberspace generation is interested in someone who, as early as 1942, was already thinking about "masks of my invention for seeing dreams in color."[57] Already in 1966 he perceived and accepted the importance of computers: "In my opinion, Karl Marx was wrong. We are at present witnessing the waning of the class struggle, thanks to cybernetics and modern technology. The proletariat itself is declining.... (People are) afraid that the intervention of human genius is decreasing. But in point of fact, the opposite is true. Cybernetic machines are getting rid of the things that encumber us; until now, first–rate brains were stockpiling a mass of useless information. It's comforting to know that from now on the machines will be supplying the dimensions of the noses in all paintings and sculptures; all we'll have to do is press a button or develop a couple of microfilms. In other times, the same task would have taken experts and scientists decades to finish. The IBM machine will clean away all the drudgery and red–tape of second–class human knowledge. Furthermore, computers are already starting to act like human beings with a psychology of their own. They've even been known to be in a bad mood or have bouts of malaria.... These same machines are exceptionally useful for painting because they can supply *points* and *features*.... They create the illusion of spatial distance on a flat surface."[58]

The strange realm of the virtual, half-way between insubstantial appearance and solid reality, is conveyed in the large format *Hallucinogenic Toreador*. Numerous copies of the Venus de Milo border a bullfighting arena and rise up out of the ground. In the foreground they lead towards the image of a small boy, as though on a perspectival time axis. This statue was, as we have seen (p. 28), an important childhood memory for the artist. Later on, in 1936, drawers were added – a strange notion. Here she is accompanied by other leitmotifs

Hallucinogenic Toreador,
1968 – 70

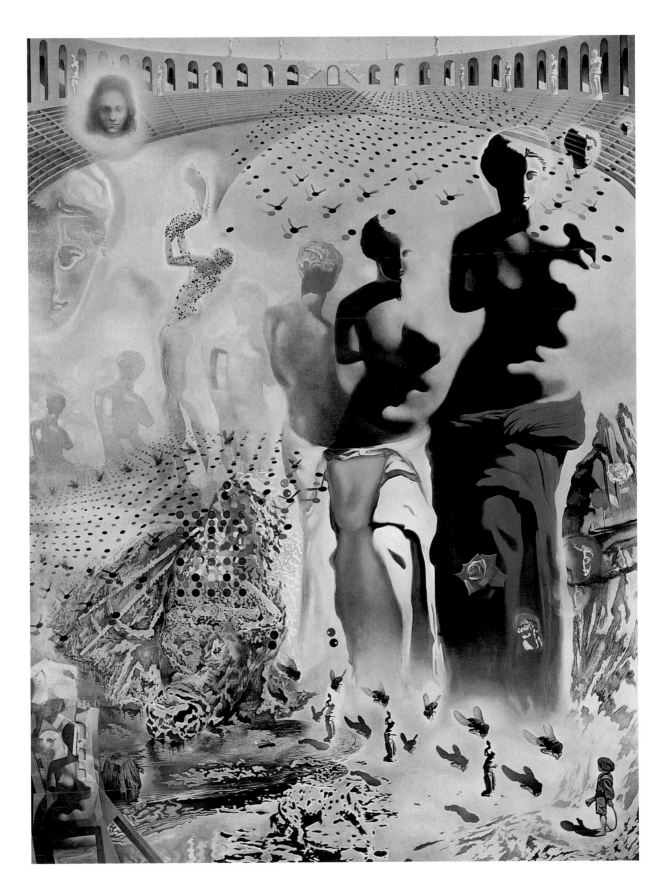

from Dalí's work: the head of Voltaire, a hint back to Millet's *Angélus* (Aphrodite's shadow looks like the praying peasant woman), Gala. The picture space, as though worked out on a calculator, is defined by points that turn out to be flies. The shimmering shadows are "mouches volantes," which momentarily cloud our vision. The body and its silhouette, the rose and its perfume, the head and its aura – all are notions that echo Dalí's favourite aesthetic principle: the double image. But his masterstroke is to turn the central Venus into the toreador: her upper body becomes his face, her breast his nose. And in answer to one of the most fascinating moments of this sculpture from the late second century B.C., where the folds of her drapery seem to be just on the point of slipping from her hip, Dalí adds a button, which at the same time fastens the shirt-collar of the tore-ador, who has slightly loosened his tie. Eros and the death wish: two sides of the same coin.

The *Cybernetic Princess* made out of computer parts spans two thousand years as a variation on the death costume (yuyi) of the imperial prince Lui Sheng that was found in 1968 in the Chinese province of Hebei. The princess's silicon chips correspond to the 2,498 small jade plates which, sewn together with gold wire, made up the ancient overall. Dalí was fascinated by this armour for eternity, which also has a neck support and nine jade stoppers to seal bodily orifices. The only opening in the costume is in the crown of the skull to allow the spirit-soul's departure for heaven.

Digitalization is demonstrated in *Gala Looking at the Mediter-ranean Sea – Which at a Distance of Twenty Metres is Transformed into a Portrait of Abraham Lincoln: Homage to Rothko*. A tile on the wall shows a black and white portrait of Lincoln, which served as a model for the light values of the whole composition. Gala's head functions as Lincoln's right eye and the bridge of his nose. The "resolution" is not very high, but the features are so characteristic that they are im-mediately recognizable. *Homage to Rothko* would seem to refer to the fact that Mark Rothko's work consists of a few, fairly homogeneous colour fields and that it is also very easily recognized. And few things or people could be identified from an image with a bit-count no higher than the number of letters in the name "Lincoln." Relying for its effect on the proximity or distance of the viewer, this work must have been produced purely on the basis of calculation since it was made in a small New York hotel room.

Cybernetic Princess,
1974, computer plates
and other computer
components

Death costume (yuyi)
with head support
(zhen) and nine plugs
for bodily orifices
(jiu sai), Western Han
Period, *c.* 113 B. C.

On Abraham Lincoln's forehead there is a floating Christ of Saint John of the Cross (the model for the original painting had been a Hollywood stuntman). *The Christ of Gala* takes the notion of floating to a still higher level. As in Pointillism, where the image composed of individual dots of colour is put together in the beholder's eye, so here the brain constructs the virtual image floating in space from the separate impressions of the right and the left eye. The two picture panels take into account the slight difference in the angles the subject is viewed from, so that, put together, they do give

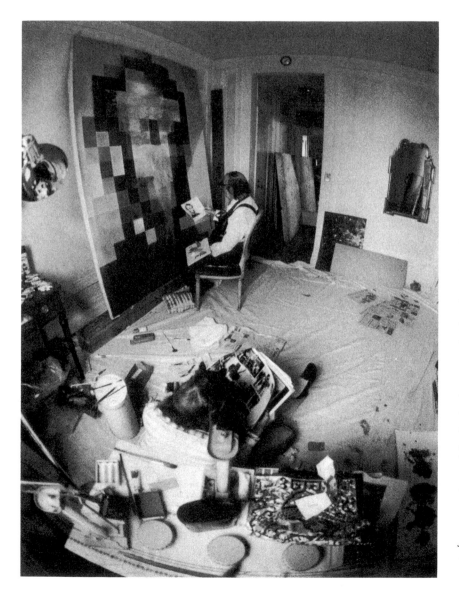

Photograph of Dalí in his room in the Hotel St. Régis, New York (room 1612) painting the picture *Gala looking at the Mediterranean Sea Which at a distance of Twenty Meters is Transformed into the Portrait of Abraham Lincoln – Hommage à Rothko,* 1975

Facing Page:
Gala looking at the Mediterranean Sea Which at a distance of Twenty Meters is Transformed into the Portrait of Abraham Lincoln, 1976

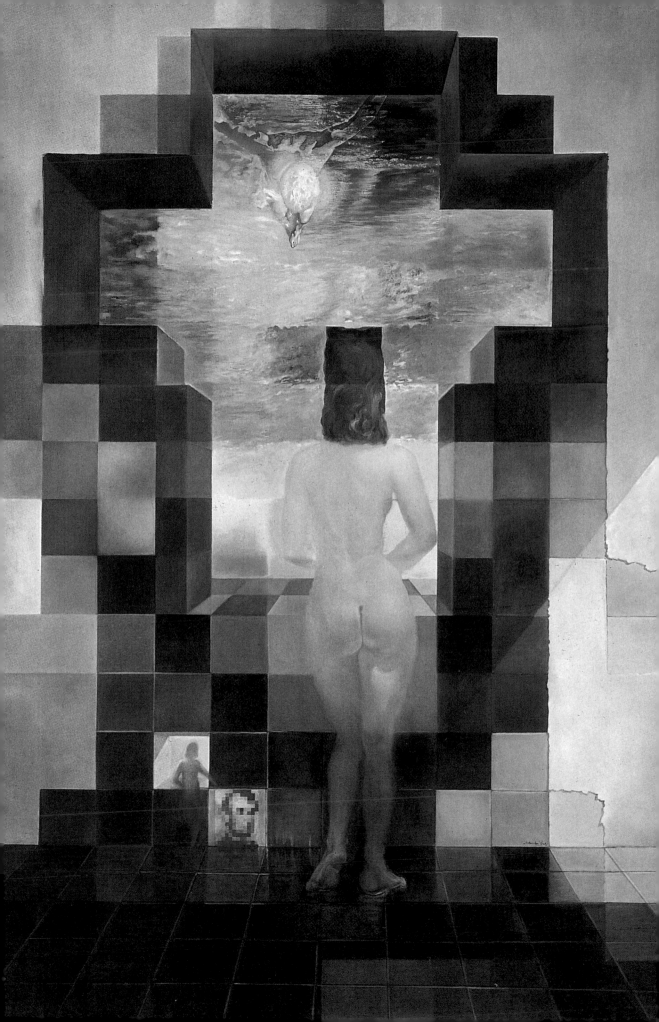

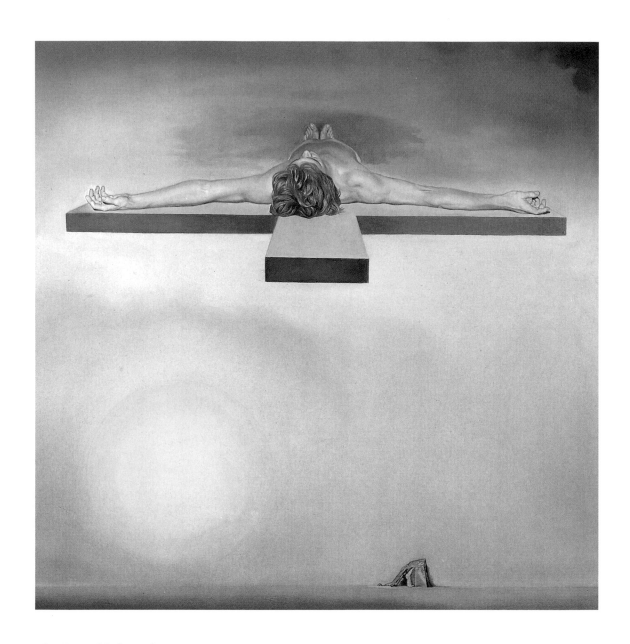

The Christ of Gala, 1978

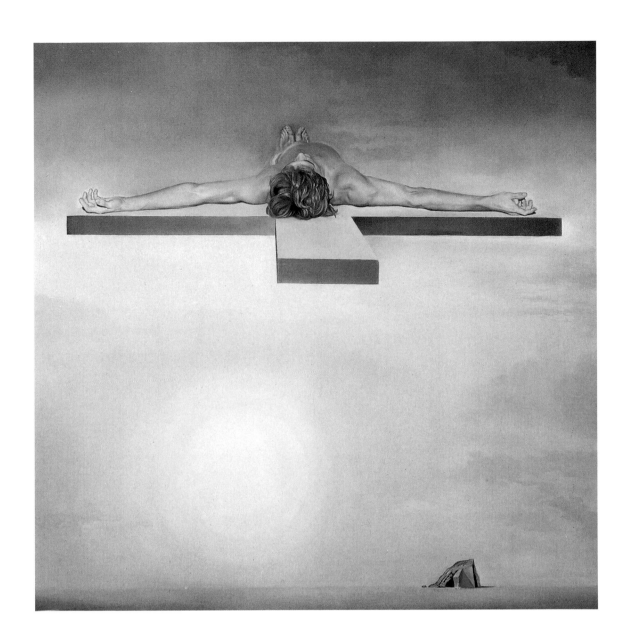

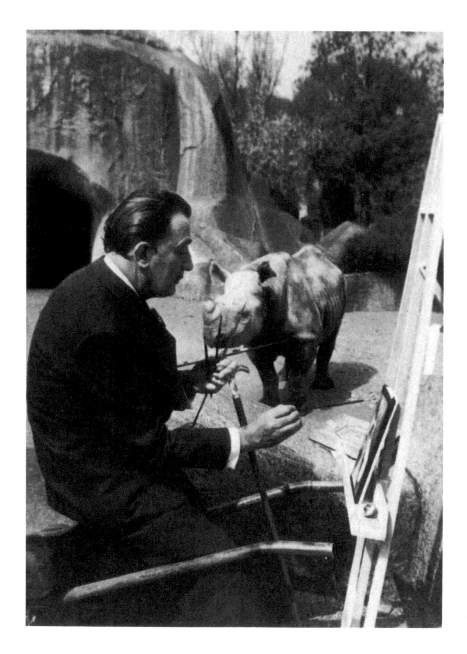

Dalí, Vermeer's
Lacemaker and the
rhinoceros in the
Vincennes Zoo, 1955

a three-dimensional effect. This stereoscopic work can either be viewed using mirrors or by crossing one's eyes. Dalí's binocular works are the logical precursors of the popular "Magic Eye" books of the 1990s, even though in his work it is much more a case of technology serving a spiritual process.

Dalí showed his intuition early on about another scientific field which has become quite popular in the last ten years: that of fractal

geometry in nature and the chaos theory. Mathematicians' favourite method to explain what those concepts mean is to reach for a cauliflower because its natural form shows what "self-similarity" is: close examination of individual florets shows that they look exactly like the "flower" itself, and each floret is again made up of tiny shoots which look like miniature cauliflowers.

Self-similarity is usually traceable through five stages until the component parts become too small to distinguish. Dalí's painting *The Face of War* manages four stages – perhaps even five if seen under a magnifying glass. Already on the cover of the catalogue for Dalí's first exhibition in New York (1933) there is a geometric drawing showing self-similarity in four stages. Before a head of broccoli appeared in any of his paintings, Dalí had already made use of a cauliflower "in natura" in a Happening. In December 1955 he spoke at the Sorbonne, about, among other things, "the morphological problem of the cauliflower": "its roses have a kind of power of expansion, almost an atomic power, a particular state of budding, a tension...." He described how the morphology of the cauliflower, like that of some other living phenomena, is characterized by logarithmic spirals. He went on to say that he had collected "research on rhinoceros horns" and established "that in Nature there has never been a more perfect example of a logarithmic spiral than the curve of the rhinoceros horn."[59] (Dalí associated a rhinoceros horn with Vermeer's *Lacemaker* in the Louvre. It was one of his favourite paintings and one which had already appeared in *Le Chien andalou*. In 1955 he confronted a rhinoceros in the zoo in Vincennes outside Paris with a reproduction of the *Lacemaker* while himself working on a copy of the painting.) The striking thing about this is that the logarithmic spiral is an excellent example of self-similarity. When enlarged, it still produces the same spiral.

In *Still Life Fast Moving* there is a direct encounter between two kinds of geometry: the Euclidian (in the red figures) and the fractal (in the broccoli). Dalí studied the applicability of both. In the area of classical proportion he was inspired by *The Geometry of Art and Life* (1946) by the Romanian count and professor of aesthetics Matila Ghyka; for the natural processes of growth, which had always interested him in shells and creatures such as snails and sea-urchins, he pored over the research findings described in *On Growth and Form* by the Scottish biologist D'Arcy Wentworth Thompson.[60]

In the late '70s, Dalí became acquainted with the mathematician René Thom and his work on catastrophe theory. The area examined by this theory has links with that of chaos theory since both deal with processes which take a sudden turn. Dalí of course handled these topological models – which he was in no position to grasp in detail – in a highly egocentric and selective manner. He liked, for example, to regard himself as a "singularity." On the other hand Thom, who was keen to apply his theories also to biological or linguistic matters, had nothing against everyday language being used to express his ideas; otherwise he would not have written that our "everyday life, on the physiological plane, may be a tissue of ordinary catastrophes, but our death is a generalized catastrophe."[61] And there would seem to be some uncanny logic that, at least according to Robert Descharnes, Dalí's last picture depicts the mathematical functions used by a catastrophe theoretician. In *The Swallow's Tail*, a graph of Thom's function of the same name – which resembles the flowing "D" in Dalí's signature – is combined with an "S" (the symbol used for the metabolic rate of oxygen-dependent bodies). The swallow's tail had already appeared with the relevant formula in his "se-

The Swallow's Tail,
1983

Queue d'aronde $V=x^7\!/5$ $V=x^5\!/5+ux^3\!/3+vx^2\!/2+wx$

*The Topological
Abduction of Europe –
Hommage à René Thom,*
1983

cond-to-last" painting, *The Topological Abduction of Europe: Hommage
à René Thom* (March 1983). The formula and its visualization (which
should be pictured in three dimensions) are to be found in Thom's
major work, *Stabilité Structurelle et Morphogénèse* (1972).[62] Formati-
ons not unlike the swallow's tail had already appeared earlier in
Dalí's pictures and he found other familiar ground in Thom's book:
the significance of bifurcation (as seen in the crutches which appear
so often in his paintings), butterfly effects, pictures of umbilics
(p. 36), and Edgerton's photograph of a falling droplet of milk at the
moment of impact. On his journey from the droplet to the galaxies,
Dalí left his space capsule just one last time to sign his life's work
with *The Swallow's Tail* before continuing on his way along the
trajectories of infinity.

Biography

1904
Salvador Dalí Domènech born as the second child of the notary Salvador Dalí Cusí and his wife Felipa Domènech Ferrés on May 11 in Figueres. Their first son had died on August 1, 1903 at the age of 21 months.

1908
Birth of his sister Ana María. Nursery school.

1910
Primary school, including French lessons.

1916
Secondary school. Drawing lessons with Juan Nuñez. Friendship with the Pitchot family. Discovers Impressionism.

1918
First drawing published.

1919
First participation in an exhibition, sales of pictures, texts published about and by Dalí.

1920 onwards
Painting holidays in the summer in Cadaqués.

1921
Death of his mother on February 6.

1922
School final exams. In September, Dalí passes the entrance examination to the Academia de San Fernando in Madrid and moves into a room in the Residencia de Estudiantes. Friendships with Luis Buñuel and Federico García Lorca.

1923
Suspended from the Academia de San Fernando for one year for disciplinary reasons.

1924
Imprisoned for 40 days in Figueres and Gerona.

1925
First solo exhibition (Galeries Dalmau, Barcelona).

Dalí and Lorca, *c.* 1927

Dalí with foil and Gala with fencer's mask in front of the double portrait *Couple with Heads full of Clouds,* 1936
Photograph: Cecil Beaton

Top:
"Bonwit Teller's" window after Dalí had smashed the glass

Middle:
Dalí at the police station with Inspector Frank Mc Farland after breaking the window

Bottom:
Dalí leaving the police station as a free man

1926
Trip to Paris and Brussels. Meets Picasso. Final expulsion from art school. Returns to Figueres.

1927
Military service for one year.

1929
Together with Buñuel, writes and makes the film *Un Chien Andalou* (first screening in Paris on June 6.) In the summer, Dalí is visited in Cadaqués by the Eluards, the Magrittes, Goemans, and Buñuel. He falls in love with Gala Eluard, his future wife. First exhibition in Paris. Breton writes the foreword to the catalogue. Rift with his father.

1930
Buys a fisherman's cottage at Port Lligat near Cadaqués. Scandalous screenings of L'Age d'Or (book by Buñuel and Dalí), in the autumn in Paris.

1934
First trip to the United States. Successful exhibition at the Julien Levy Gallery, New York.

1936
July: Gives lecture in London wearing a diving suit. December: Second trip to the United States. Featured on the cover of *Time*, December 14.

1937
Spends time in Italy.

1938
July 19: Dalí visits Sigmund Freud in London.

Dalí, *c.* 1933
Photograph: Man Ray (ADAGP)

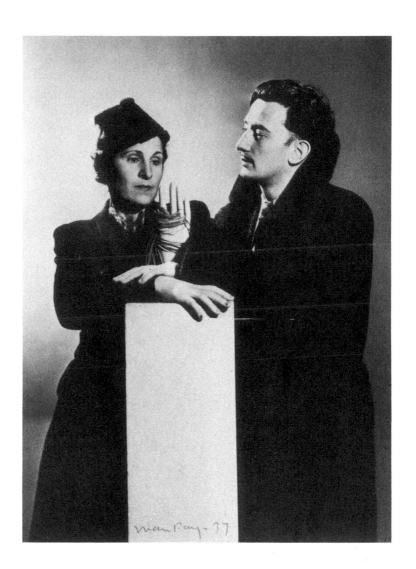

Dalí and Gala in their apartment
in rue de l'Université, 1937
Photograph: Man Ray

1939
Returns to New York, where the
press hails him as "one of the
richest young painters." In
March he smashes the window
at Bonwit Teller's after the man-
agement change the window
display which he had been com-
missioned to create.
May/June: Creates the environ-
ment *The Dream of Venus* for the
World's Fair in New York. When
he is forbidden to add a fishhead
to Botticelli's *Venus*, he publishes
the manifesto "Declaration of the
Independence of the Imagination
and of the Rights of Man to his
Own Madness."

1940 – 1948
Exile in the United States
(Virginia, California, New York).

1941
Continues to broaden his range
of activities to include ballet,
opera, film, fashion, jewellery,
illustration, advertising, and
more.

1942
October: publication of his
autobiography *The Secret Life of
Salvador Dalí.*

Gala and Dalí working on
Dream of Venus

1944
Stage designs for dream
sequences in Hitchcock's film
"Spellbound".

Top of page:
Dalí with Alfred Hitchcock and
James Basevi

Above:
Dalí with Gregory Peck and
Ingrid Bergman

1948
Returns to Port Lligat in the
summer.

1949
November 23: Audience with
Pope Pius XII.

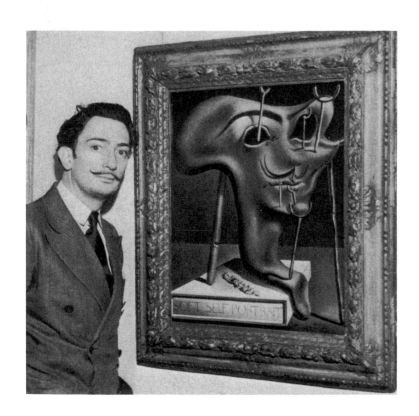

Dalí in front of his picture
*Soft Self-Portrait with Fried
Bacon,* 1941

Dalí reading *The Secret Life of Salvador Dalí* to Gala and Caresse Crosby

1952
Lectures in the United States on the links in art between atomic physics and religious belief.

1955
In the Vincennes Zoo outside Paris he confronts a rhinoceros with a reproduction of Vermeer's *Lacemaker* (which had already appeared in the *Chien Andalou*). In December, gives a lecture at the Sorbonne.

1956
Received in the Pardo Palace by Franco. He and Gala marry in a church ceremony in Montrejic.

1959
Audience with Pope Johannes XXIII.

1964
Receives the Grand Cross of the Order of Isabella.

1969
Buys a castle for Gala in Púbol.

Dalí, *Galarina*, 1944 – 45

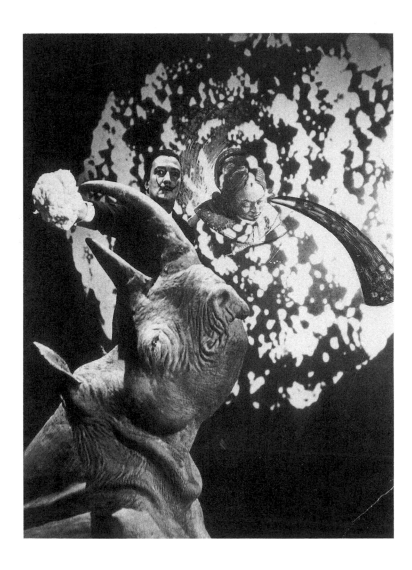

Dalí with Cauliflower and Rhinoceros, 1955
Photograph: Philippe Halsman

1974
Opening of the Teatre-Museu
Dalí in Figuereas.

1978
Admitted to the Académie des
Beaux-Arts, Paris.

c. 1980 onwards
Suffering from Parkinson's
disease.

1982
Opening of the Dalí Museum in
St. Petersburg, Florida. Gala dies
on June 10. King Juan Carlos ele-
vates Dalí to the nobility.

1989
January 23: Salvador Dalí dies in
Figueres.
Bequeaths his estate to the King-
dom of Spain and the Independ-
ent Region of Catalonia.

Dalí in front of his painting
The Swallow's Tail, Púbol Castle,
1983, Photograph: Descharnes

Admission to the Académie
des Beaux-Arts,
Paris on 26 May 1978
Photograph: H. Roger Viollet

Dalí in Catalonian beret, August
1977, Photograph: Werner Kohn

Footnotes

1 *Salvador Dalí: The Early Years*, exh. cat., ed. by Michael Raeburn, London, New York 1994, p. 21.

2 Salvador Dalí, *Diary of a Genius*, London 1990, p. 171.

3 Rafael Benet in *La Veu de Catalunya*, October 20, 1926, as quoted in Fèlix Fanés, "The first image – Dalí and his critics: 1919 to 1929," (see n. 1), p. 91.

4 Unlike Brigitte Bardot, he did not find fame hard to bear. "It's like money, if someone opens the door and brings in a mountain of gold, I'll accept it without flinching; the same holds true for popularity, I accept it just as easily." (Alain Bosquet, *Conversations with Dalí*, New York, 1969, p. 80).

5 Ana María Dalí, *Salvador Dalí visto por su hermana*, Barcelona 1983, p. 30 (Catalan, 1st edition, 1949).

6 Ralf Schiebler, ed., *Dalí Lorca Buñuel. Aufbruch in Madrid*, Stuttgart 1993, p. 8.

7 Salvador Dalí, *The Secret Life of Salvador Dalí*, trans. by Haakon M. Chevalier, London, 2nd edition, 1949, p. 153.

8 See n. 7, p. 15; the same feeling when he was a 14 or 15-year-old: p. 133.

9 See n. 7, pp. 11-14, pp. 35-62.

10 See n. 7, p. 66.

11 "Three Essays on Sexuality" (1905) in Sigmund Freud, *The Complete Works*, trans. under the editorship of James Strachey, 32 vols., London 1953, VII, p. 173. The following references: p. 200 and p. 197.

12 See n. 7, p. 73.

13 See n. 11, p. 205.

14 See n. 7, p. 84.

15 See n. 7, p. 139.

16 Trans. from Otto Rank, *Sexualität und Schuldgefühl*, Vienna 1926, p. 11 and p. 16.

17 See n. 7, p. 15. See also Dalí's "technique of retardation," p. 140, and Rank (see n. 16), p. 13; for parallels between retardation and saving money, see Rank, p. 33, and Bosquet (see n. 4), p. 84.

18 Meredith Etherington-Smith, *Dalí. A Biography*, London 1992, p. 23.

19 Robert Descharnes and Gilles Néret, *Salvador Dalí 1904-1989. Das malerische Werk*, Cologne 1993, p. 148.

20 "A Special Type of Choice of Object Made by Men" (1910), in Sigmund Freud, *The Complete Works*, (see n. 11), XI, p. 165.

21 Bosquet (see n. 4), p. 84.

22 Luis Buñuel, *My Last Breath*, trans. by Abigail Israel, London 1984, p. 97.

23 Letter of October 3, 1928, quoted in exh. cat. (see n. 1), p. 39.

24 See n. 7, p. 213.

25 This was because of the sticky slime left on his neck by a squashed grasshopper (see n. 7, p. 129). When he discovered a certain leaf-insect, he called it his "morros de con" (the labia of the female pudenda), see n. 7, p. 69.

26 Etherington-Smith (see n. 18, p. 42) supposes that Dalí's father and Tieta "had probably been having an affair for some years before Dalí's mother died. Certain paintings Dalí did when young … contain hints that he may have seen his father and his aunt in compromising situations."

27 See n. 7, p. 248.

28 Otto Rank, *The Incest Theme in Literature and Legend*, trans. by Gregory C. Richter, Baltimore and London 1992, pp. 85-87.

29 See n. 7, p. 248.

30 The father complex is further worked out here as though the group on the left were a kind of footnote. (p. 24)

31 See n. 7, p. 100.

32 See n. 20, in particular p. 169 f.

33 "Delusions and Dreams in Jensen's Gradiva" (1906-07) in Sigmund Freud, *The Complete Works*, (see n. 11), IX, p. 90.

34 See n. 7, p. 233. This can only be the case in so far as Dalí first read Jensen's novella and then Freud's interpretation of it. In doing so, he would have acted on Freud's request to his readers to do just that. But at that time there was no separate French or Spanish edition of Jensen's text. What Dalí read must have been a book published by Gallimard in 1931 which contained Jensen's novella in the first half and Freud's study in the second.

35 See n. 33, p. 17.

36 See n. 7, p. 58 ff., p. 75 ff., p. 91 and p. 229 ff.

37 Chagall, too, was a Gradivus. In the words of Maiakovski: "May the Lord grant each one should step out (shagal) like Chagall."

38 Hans Prinzhorn says, "As we have often observed, … double meanings are characteristic of the schizophrenic imagination." (*The Artistry of the Mentally Ill*, New York 1972, p. 138). A watercolor by the patient Klotz called 'Keller, Wirtshaus, Salon, Stall in Einem' serves as an example of this, although of course infinitely far removed from Dalí's refined constructs. In the exhibition catalogue *Salvador Dalí, Retrospektive 1920-1980*, Munich 1980, p. 15, it is suggested that Dalí might have been drawing on Prinzhorn's book for his famous statement–probably first used by him in a lecture in late 1934 – that "the only difference between me and a madman is that I am not mad." It is true that in 1933 in a letter to the critic Elias he directs the latter's

attention to "Prinzhorn's book which I am forced to think you know nothing of" and continues, "We are aspiring to a way of thought which compares to that of madmen, with the single difference that we are not mad." (As quoted in Etherington-Smith, see n. 18, p. 206). This is his own formulation and not to be found in Prinzhorn's book. Prinzhorn does, nevertheless, point out the "astonishing fact that the schizophrenic outlook and that displayed in recent art can be described only by the same words ..." and warns against people jumping to the conclusion that "a painter is mentally ill because he paints like a given patient ..." He continues: "If we carefully observe the arts today we find a number of tendencies active in all of them, the fine arts as well as all branches of literature, to which only a genuine schizophrenic could do justice. Mind you, we are far from trying to prove the presence of symptoms of mental illness in these arts, but we do find an instinctive affinity for nuances which are familiar to us in schizophrenics." (pp. 271-272)

39 See n. 7, p. 67 and p. 51 f.
40 In Sigmund Freud, *The Complete Works* (see n. 11), XXI, p. 119.
41 See n. 7, p. 244 and pp. 107-11.
42 When it looked highly unlikely that the Dalís would find the fare for their first trip to the United States, the "myth Danaë was realised, and after three days of furiously jerking fortune's cock it ejaculated in a spasm of gold!" (see n. 7, p. 328 f.) Later it turned out that it was none other than Picasso who had played Zeus.
43 See n. 7, p. 293.
44 See n. 5, p. 17 f.

45 See n. 7, p. 225.
46 See n. 7, p. 315 f.
47 Tim McGirk, *Wicked Lady: Salvador Dalí's Muse*, London 1989, p. 89.
48 See n. 47, p. 124.
49 "Character and Anal Erotism," in Sigmund Freud, *The Complete Works*, (see n. 11), IX, p. 173. Freud describes the fact that certain individuals recall having experienced pleasure in childhood in holding back their stool and "doing all sorts of unseemly things with the faeces that had been passed." Dalí, remembering his childhood (in Salvador Dalí, *Meine Leidenschaften*, aufgezeichnet von Louis Pauwels, Gütersloh 1969, p. 83), provides us with the perfect example of Freud's thesis: "Red in the face, pressing my buttocks together and first on one foot and then the other, I would dance hrough the house. People would look at me anxiously. I would flee, holding back my treasure in my overloaded intestines. I would search out the most unexpected place to dispose of it: a drawer, a shoe box, the sugar tin. With tears in my eyes, breathless, I would still wait. In the end, trembling convulsively and with voluptuous regret, I would relieve myself into the chosen hiding place."
50 Fleur Cowles, *The Case of Salvador Dalí*, London 1959. p. 165.
51 Ralf Schiebler, *Giorgio de Chirico and the Theory of Relativity. Lecture given at Stanford University*, Wuppertal 1988.
52 *The Economist*, February 25, 1995.
53 See n. 7, p. 107.
54 *The New York Times*, December 27, 1954.
55 See n. 18, p. 296.
56 Pauwels, see n. 49, p. 137.

57 See n. 7, p. 296.
58 Bosquet (see n. 4), p. 67 ff. and p. 87 f.
59 "Aspects phénoménologiques de la méthode paranoïaque-critique" (December 17, 1955) in Salvador Dalí, *Oui*, Paris 1971.
60 From Cowles (see n. 50, p. 190), it is clear that he owned a copy of this in 1950.
61 René Thom, *Structural Stability and Morphogenesis*, trans. by D. H. Fowler, Reading, MA, 1975, p. 251.
62 $V = \frac{1}{5}x^5 + \frac{1}{3}ux^3 + \frac{1}{2}vx^2 + wx$, see n. 61, p. 64, for the following see p. 107, p. 77 and illus. 12.

Bibliography

Bosquet, Alain. *Conversations with Dalí,* New York 1969.

Cowles, Fleur. *The Case of Salvador Dalí,* London 1959.

Dalí, Ana María. *Salvador Dalí visto por su hermana,* Barcelona 1949.

Dalí, Salvador. *Diary of a Genius,* trans. from the French by Richard Howard, London 1990.

Dalí, Salvador avec Louis Pauwels *Les Passions selon Dalí,* Paris 1968.

Dalí, Salvador. *The Unspeakable Confessions of Salvador Dalí,* as told to André Parinaud, London 1977.

Dalí, Salvador. *Gesammelte Schriften,* Munich 1974.

Dalí, Salvador. *The secret Life of Salvador Dalí,* trans. by Haakon M. Chevalier, New York 1942.

Descharnes, Robert. *Dalí de Gala,* Lausanne 1962.

Descharnes, Robert. *Salvador Dalí. Sein Werk – Sein Leben,* Cologne 1984.

Descharnes, Robert and Descharnes, Nicolas. *Salvador Dalí,* Lausanne 1993.

Descharnes, Robert, and Néret, Gilles. *Salvador Dalí 1904 – 1989. Das malerische Werk,* Cologne 1993.

Etherington-Smith, Meredith. *Dalí. A Biography,* London 1992.

Sánchez Vidal, Augustin. *Buñuel, Lorca, Dalí: El enigma sin fin,* Barcelona 1988.

Santos Torroella, Rafael. *Dalí Residente,* Madrid 1992.

Schiebler, Ralf. *Salvador Dalí: Meisterwerke der dreißiger Jahre,* Munich 1989.

Schiebler, Ralf (ed.). *Dalí, Lorca, Buñuel: Aufbruch in Madrid,* Stuttgart 1993.

Exhibition catalogues

Salvador Dalí. Retrospektive 1920 – 1980, Centre Pompidou, Munich 1980.

400 obres de Salvador Dalí, 1914 – 1983, Madrid, Barcelona 1983.

Salvador Dalí 1904 – 1989, Stuttgart, Zurich 1989.

Salvador Dalí: the early years, London, New York, Madrid, Figueres 1994 – 1995.

Photo Credits

The publisher would like to thank Descharnes & Descharnes in particular, as well as the following institutions for kindly providing the illustrations listed below:

Artothek, Peissenberg: pages 6, 24, *25*

Descharnes & Descharnes SARL, Paris: pages 9, 16, 43, 47 top, 64 top, 65, 82, 87, 106, 120 top and bottom, 121 bottom (center)

Fundació Gala-Salvador Dalí, Figueres: pages 11, 19, 54, 71, 73, 74, 86, 89, 105 top, 112, 113

Magnum/Focus, Hamburg: pages 9, 68

Musées Royaux des Beaux-Arts de Belgique, Brussels: pages 4, *91*

Museo nacional centro de arte Reina Sofia, Madrid: pages 15, 20, 21, 26, *31, 36, 51,* 52, 78, 80

Photographie Giraudon, Vanves: page 60

Man Ray Trust: pages 116 top, 117

The Salvador Dalí Museum Inc., St. Petersburg, Florida: pages 17, 23, 35, 38, 39, *41,* 57, 83, 85, 92, 99, 101, 103

List of Illustrations

Listed according to page number.
Where illustrated more than once, the italicized number refers to the picture in full.

The Accommodations of Desires 1929
Oil and collage on board
8 ¾ x 13 ¾ in. (22 x 35 cm)
The Jacques and Natasha Gelman
Collection
Page 45

William Tell and Gradiva 1931
Oil on copper
11 ¾ x 9 ½ in. (30 x 24 cm)
Fundació Gala-Salvador Dalí,
Figueras
Page 47 top

Erotic Drawing 1931
Indian ink and pencil on paper
11 x 8 ¾ in. (28 x 22 cm)
André-François Petit Collection,
Paris
Page 47 bottom

Drawing from *The Secret Life of
Salvador Dalí*
(page 239)
Page 49

The Invisible Man 1929–32
Oil on canvas
55 x 32 in. (140 x 81 cm)
Museo Nacional Centro de Arte
Reina Sofía, Madrid
Pages 51, 52

The Butterfly Hunt 1929
Illustration for *La Femme Visible*,
published in 1930,
Indian ink on paper
21 ¾ x 16 ¼ in. (55.5 x 41.5 cm)
André-François Petit Collection,
Paris
Page 53

The Spectre of Sex-Appeal 1934
Oil on panel
7 x 5 ½ in. (17.9 x 13.9 cm)
Fundació Gala-Salvador Dalí,
Figueras
Page 54

The Weaning of Furniture-Nutrition
1934
Oil on panel
7 x 9 ½ in. (18 x 24 cm)
The Salvador Dalí Museum,
St. Petersburg, Florida
Page 57

The Horseman of Death 1935
Oil on canvas
25 ½ x 21 ¼ in. (65 x 54 cm)
André-François Petit Collection,
Paris
Page 58

Autumn Cannibalism 1936
Oil on canvas
25 ½ x 25 ¾ in. (65 x 65.2 cm)
Tate Modern, London
Page 60

*Soft Construction with Boiled Beans:
Premonition of Civil War* 1936
Oil on canvas
39 ½ x 39 in. (100 x 99 cm)
The Philadelphia Museum of Art,
USA
Page 61

Pablo Picasso
Guernica 1937
Oil on canvas
138 ¼ x 308 in. (351 x 782 cm)
Museo del Prado, Madrid
Page 62 (Detail)

*The Debris of an Automobile Giving
Birth to a Blind Horse Biting a
Telephone* 1938
Oil on canvas
21 ¼ x 25 ½ in. (54 x 65 cm)
The Museum of Modern Art, New
York
Page 63

*Untitled (For a U.S. army Campaign
Against Sexually Transmitted Diseases)*
1942
Oil on canvas
17 x 14 in. (43.2 x 35.6 cm)
Private Collection
Page 64 top

Vasily Vasilyevich Vereshchagin
Apotheosis of War 1871
Tretiakov Gallery, Moscow
Page 64 bottom

The Face of War 1940
Oil on canvas
25 ¼ x 31 in. (64 x 79 cm)
Boymans-van Beuningen Museum,
Rotterdam
Page 65

*The Poetry of America:
The Cosmic Athletes* 1934
Oil on canvas
46 x 30 ¾ in. (116 x 79 cm)
Fundació Gala-Salvador Dalí,
Figueras
Page 71

Surrealist Composition 1928
Oil and sand on wood
28 ¾ x 24 ½ in. (79.7 x 62.5 cm)
Fundació Gala-Salvador Dalí,
Figueras
Page 72

The Enigmatic Path 1981
Oil on canvas
54 ¾ x 37 in. (140 x 94 cm)
Fundació Gala-Salvador Dalí,
Figueras
Page 73

Galatea of the Spheres 1952
Oil on canvas
25 ½ x 21 ¼ in. (65 x 54 cm)
Fundació Gala-Salvador Dalí,
Figueras
Page74

The Persistence of Memory 1931
Oil on canvas
9 ½ x 13 in. (24 x 33 cm)
The Museum of Modern Art,
New York
Page 76

The Premature Ossification of a Station
1930
Oil on canvas
12 ½ x 10 ½ in. (31.5 x 27 cm)
Private collection
Page 77

Melancholic Atom and Uranium Idyll
1945
Oil on canvas
25 ½ x 33 ½ in. (65 x 85 cm)
Museo Nacional Centro de Arte
Reina Sofía, Madrid
Pages 78, 80

The Three Sphinxes of Bikini 1947
Oil on canvas
11 ¾ x 19 ¾ in. (30 x 50 cm)
Private collection, Geneva
Page 81

Front cover and spine: *Hallucinogenic Toreador*, 1968–70, details; see p. 103
Page 1: Salvador Dalí as a magician, photograph from *The Fantastic Universe of Salvador Dalí*, Paris 1989
Frontispiece: *One Second before Awakening from a Dream Caused by the Flight of a Bee around a Pomegranate*, 1944, oil on canvas, 51 x 40.5 cm, Museo Thyssen-Bornemisza, Madrid
Page 4 and back cover: *Burning Giraffe*, 1936/37, oil on panel, 35 x 27 cm, Kunstmuseum Basel, Basle

The Library of Congress Cataloguing-in-Publication data is available; British Library Cataloguing-in-Publication Data: a catalogue record for this book is available from the British Library; Deutsche Bibliothek holds a record of this publication in the Deutsche Nationalbibliografie; detailed bibliographical data can be found under: http://dnb.ddb.de

Prestel books are available worldwide. Please contact your nearest bookseller or one of the following Prestel offices for information concerning your local distributor:

Prestel Verlag
Königinstrasse 9, 80539 Munich
Tel. +49 (89) 38 17 09-0; Fax +49 (89) 38 17 09-35

Prestel Publishing Ltd.
4 Bloomsbury Place, London WC1A 2QA
Tel. +44 (020) 7323-5004; Fax +44 (020) 7636-8004

Prestel Publishing
900 Broadway, Suite 603, New York, NY 10003
Tel. +1 (212) 995-2720; Fax +1 (212) 995-2733

www.prestel.com

Translated from the German by Fiona Elliott, Edinburgh
Copy-edited by Jacqueline Guigui-Stolberg

Cover design: Matthias Hauer
Typesetting: Reinhard Amann, Aichstetten
Typeface: Caslon Buch
Origination: Karl Dörfel GmbH, Munich
Printing: Appl, Wemding
Binding: Oldenbourg, Monheim

Printed in Germany on acid-free paper
ISBN 3-7913-3349-6